IMAGES
of America

LONG ISLAND
AIRCRAFT
MANUFACTURERS

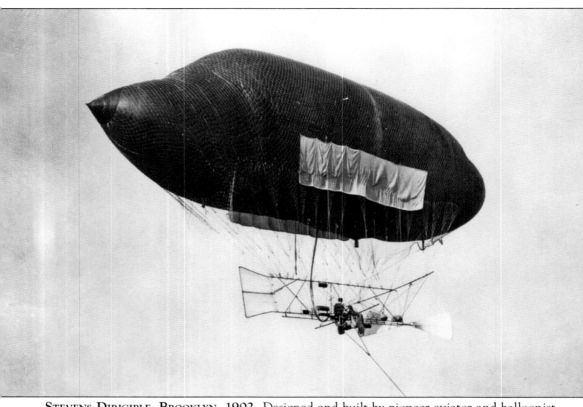

STEVENS DIRIGIBLE, BROOKLYN, 1902. Designed and built by pioneer aviator and balloonist A. Leo Stevens in Brooklyn, this hydrogen-filled airship was 85 feet long. It was powered by a 7.5-horsepower, single-cylinder DeDion-Bouton engine. When successfully flown from Manhattan Beach, Brooklyn, on September 30, 1902, this became the first manned powered aircraft to fly in the United States (albeit lighter-than-air). (Courtesy National Air and Space Museum.)

ON THE COVER: NEW SEVERSKY BT-8S ON THE LINE, FARMINGDALE, 1936. Essentially a military version of the SEV-3, the Seversky outperformed all other entrants in the 1935 Air Corps competitions for a new basic trainer. Thus, Seversky won a production contract for 35 aircraft, and it was the beginning of a long and fruitful relationship between the U.S. Air Corps/Air Force and Seversky/Republic. (Courtesy Cradle of Aviation Museum.)

IMAGES
of America

LONG ISLAND
AIRCRAFT
MANUFACTURERS

Joshua Stoff

ARCADIA
PUBLISHING

Copyright © 2010 by Joshua Stoff
ISBN 978-0-7385-7336-6

Published by Arcadia Publishing
Charleston, South Carolina

Printed in the United States of America

Library of Congress Control Number: 2010921016

For all general information contact Arcadia Publishing at:
Telephone 843-853-2070
Fax 843-853-0044
E-mail sales@arcadiapublishing.com
For customer service and orders:
Toll-Free 1-888-313-2665

Visit us on the Internet at www.arcadiapublishing.com

CONTENTS

ACKNOWLEDGMENTS

Although this book is the culmination of many years of tracking down obscure local aircraft manufacturers and photographs of their products, the author would also like to thank the following for their assistance in this project: Tyler Stoff (technical assistance), Julia Blum (Cradle of Aviation Museum Archives), John Underwood (historian), and Leo Opdycke for showing us all the right way to do such a compilation.

Unless otherwise noted, all photographs are from the archives of the Cradle of Aviation Museum.

INTRODUCTION

Aviation was not born on Long Island, New York, but it certainly grew up here. Significant manufacturing began in the early 20th century, boomed in the war years, and, except for commercial aviation, declined as a major force between her shores and on her plains. Long Islanders helped transform aviation from a dangerous sport to a viable means of transportation. They also produced a large portion of the nation's aerial arsenal in times of war. From the first frail biplanes, to the can-do warbirds of World War II, to the sleek fighters of the jet age, the many aviation companies that developed on Long Island helped make aviation the integral part of our world that it is today. Without doubt, some of the most famous American aircraft ever produced were built by the hands of Long Islanders. This work is intended to be a brief survey of the surprisingly large number of aircraft manufacturers that once called Long Island home.

The first aircraft manufacturers sprang up in the early years of the 20th century in places largely determined by geography. Long Island was adjacent to America's most populous city, and the central area of Nassau County, known as the Hempstead Plains, was the only natural prairie east of the Allegheny Mountains. This proved to be an ideal flying field, treeless and flat, with only tall grasses and scattered farmhouses. It was an ideal place to start building airplanes—a natural airfield, close to a major city (with its financial backers), with good road and rail transportation. In addition, there was an abundant supply of skilled labor as well as a large immigrant pool eager to work. Thus, Long Island was to be the scene of intense aviation activity for the better part of the 20th century.

Aircraft manufacturing took firm hold on Long Island during World War I. In 1917, the famed Curtiss Aircraft Company opened its experimental factory in Garden City. This was the first factory in the world built just for the research and development of new types of aircraft. Smaller firms also began building fighters, bombers, and trainers on the island during the first war.

In the following decades, more than 80 firms came to build aircraft on Long Island. In fact, during the Golden Age of aviation in the 1920s and 1930s, there were more aircraft manufacturers on Long Island than in any other area of the United States. This was due to the number of good military and civilian flying fields, as well as the large number of wealthy Long Islanders interested both in purchasing new aircraft as well as backing the new firms. Some of these firms lasted for decades and became famed builders of many historic aircraft, such as Grumman, Republic, Curtiss, Fairchild, and Sikorsky. Most, however, only built one or a few aircraft and rapidly faded into obscurity.

There is no question that Long Island–built aircraft helped America and its allies achieve victory during World War II. U.S. fighter operations were clearly dominated by Long Island–built warplanes. The demands of war grew several small stable companies into a tremendous aircraft industry on Long Island. In fact, by 1945, more than 100,000 people worked in the aviation industry here, making aviation by far the island's largest employer.

Unfortunately, complete aircraft are no longer built on Long Island. Most companies went bankrupt during the Depression or at some point moved to sunnier (and less expensive) locations.

However, the building of aircraft on Long Island was continuous throughout almost the entirety of the 20th century, from aviation's earliest days when frail airplanes were built in carriage sheds.

There have been many books written about the few well-known manufacturers covered in this volume. However, in the course of gathering data and locating photographs of the 80-plus manufacturers who have at one time called Long Island home, equal billing was given to the many obscure builders who may have only produced one or a dozen aircraft before fading into history. Each, nonetheless, contributed to the steady progress of aviation in their own way, and they also deserve to be documented. Researching Long Island aircraft manufacturers, even the most obscure ones, has been a special interest of mine during the past 20 years. Thus, I have made a concerted effort to locate information and photographs of every company that ever built an airplane on Long Island. This book is the result of that research.

Long Island aircraft production is a virtual microcosm of the history of aviation in the United States. From the first spindly biplanes, to the modern warplanes still flying today, it all happened on Long Island.

A note on organization and selection: the manufacturers that follow are ordered by county and are arranged alphabetically within that section. This work is a survey and does not include every type of aircraft produced on Long Island. When covering the major manufacturers, only a sampling of the variety of aircraft they produced, focusing on the more important types, is included. When covering the smaller builders, not every homebuilt produced on the island is included. One-of-a-kind designs are included only if they were unique, important, or there was some intent of production. All photographs, unless otherwise noted, are from the Cradle of Aviation Museum archives.

One

BROOKLYN

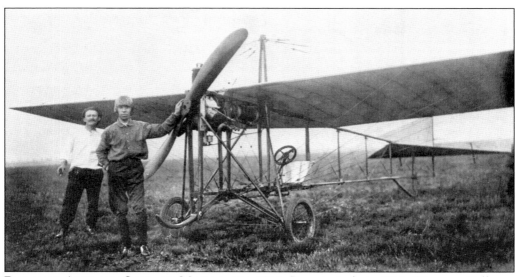

BELLANCA AIRPLANE COMPANY MONOPLANE, 1911. Born in Italy in 1910, Giuseppe Bellanca (pictured above at right), an engineer by training, immigrated to America and immediately began building this monoplane in Brooklyn. Constructed in the back of the family bakery, the high-wing monoplane was powered by a 30-horsepower Anzani engine. Flown successfully in Mineola, Bellanca built two more copies and with them operated a flying school on the Hempstead Plains Airfield in Garden City. Bellanca moved to Maryland in 1916 and operated a successful aircraft manufacturing company into the 1950s.

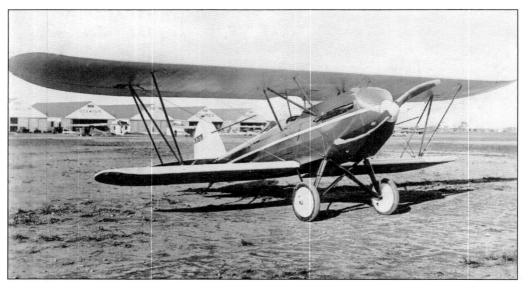

BRUNNER WINKLE AIRCRAFT CORPORATION MODEL A BIRD, ROOSEVELT FIELD, 1929. This firm was founded by William Winkle, Jacob Finkle, and brothers Joseph, August, and Henry Brunner in Glendale, Brooklyn, in order to build the Bird biplane designed by Michael Gregor. In production between 1928 and 1931, the Bird was a fairly successful private aircraft. Final assembly and flight-testing of the Bird was done at Roosevelt Field in Garden City. Originally powered by a 90-horsepower Curtiss OX-5 engine, the Bird was able to carry three people in its two open cockpits. At the time, the aircraft was referred to as "the bird from Brooklyn."

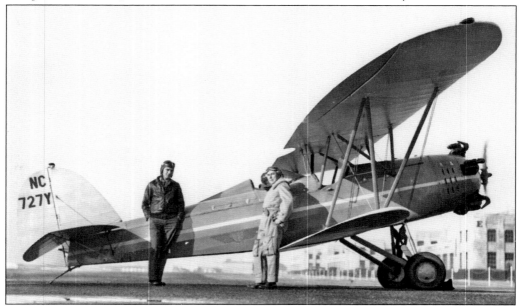

BRUNNER WINKLE MODEL B BIRD, 1930. After the supply of war surplus Curtiss OX-5 engines was exhausted, the Birds were powered by 100-horsepower Kinner K-5 engines. Noted aviatrix Elinor Smith set an altitude record in a Bird, and Charles Lindbergh taught his wife, Anne, to fly in one on Long Island. This Bird is posed on the flightline at Roosevelt Field with the engine running.

BRUNNER WINKLE MODEL E CABIN BIRD, ROOSEVELT FIELD, 1930. The last production model of the Bird featured an enclosed cockpit. However, only one was built, and a total of 239 Brunner Winkle Birds rolled out of the factory before weak sales during the Depression forced the company into bankruptcy in 1931. In 1979, Glendale was granted a Queens post office address.

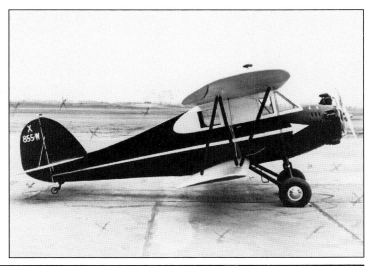

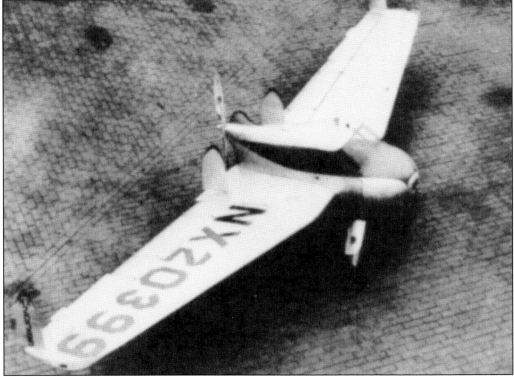

MANAGEMENT AND RESEARCH, INC., MODEL H-70, FLOYD BENNETT FIELD, 1938. An all-metal, tailless monoplane, the H-70, designed by Thomas Hoff, was manufactured for the Department of Commerce as part of a program to develop new types of safe airplanes. Powered by a 95-horsepower Menasco pusher engine, the aircraft featured a large rectangular wing with rudders mounted at the wingtips. At one point after a crash, the aircraft was modified and referred to as the Tuscar Metals H-71. Built at Floyd Bennett Field in Brooklyn, the aircraft proved difficult to fly, and it only accumulated about 60 hours of flight time before finally crashing in 1945. This was the only "flying wing" built on Long Island.

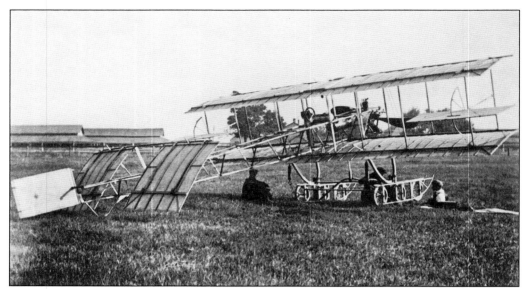

Sperry Tractor Biplane, Sheepshead Bay, 1910. Lawrence Sperry, son of noted inventor Elmer Sperry, first became interested in aviation as a teenager after seeing Henri Farman make a short flight in Brooklyn in 1908. Thus, in the summer of 1910, at age 17, he built an aircraft from an original design on the second floor of his parents house in Flatbush. First flown as a glider, a 60-horsepower Anzani engine was procured, and the aircraft was then successfully flown from the Sheepshead Bay racetrack. The aircraft was also equipped with a unique multi-wheeled landing gear for use on rough terrain. This was certainly one of the first tractor biplanes built in the United States.

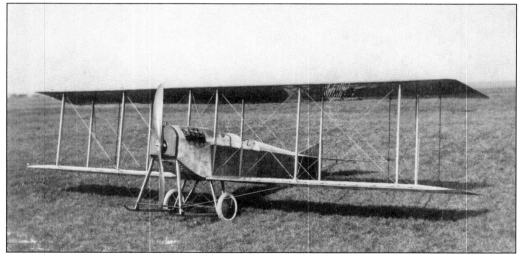

United Eastern Aeroplane Corporation Tractor Biplane, 1917. Frederick Hild and Edward Marshonet were both formerly with the American Aeroplane Supply House. They founded their firm, United Eastern, in Sheepshead Bay, Brooklyn, and attempted to produce a two-place military trainer during World War I. Powered by a 120-horsepower Maximotor, approximately five were built, with one being tested by the Air Service. In spite of its fine flying qualities, United Eastern was unable to compete with the price of the Curtiss Jenny; thus the firm folded in 1918. (Courtesy John Underwood.)

Two

QUEENS

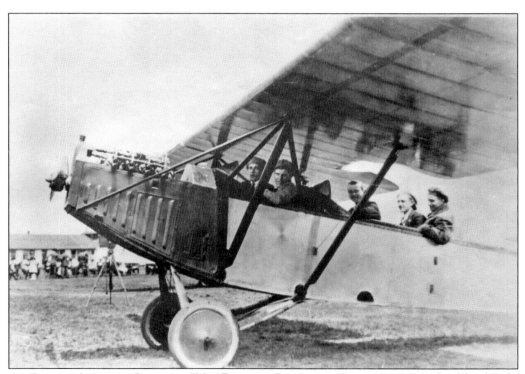

AIR LEADER AIRPLANE COMPANY, JN-4 PARASOL, ROOSEVELT FIELD, 1926. Based in Floral Park, Queens, Air Leader modified war surplus Curtiss JN-4's, making them into three-place high-wing monoplanes. Still powered by a World War I surplus 90-horsepower Curtiss OX-5 engine, it is unknown how many were modified in this fashion. This must be a publicity photograph, as it is doubtful the aircraft could have carried five.

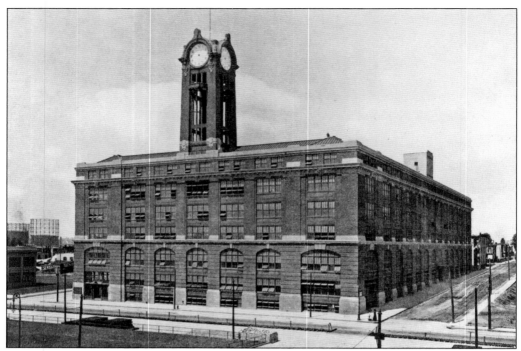

BREWSTER AERONAUTICAL CORPORATION FACTORY, LONG ISLAND CITY, QUEENS, C. 1939. Organized in Queens in 1932, Brewster Aeronautical was the successor to the noted Brewster Company, founded in 1810, that had previously built high-end horse-drawn carriages and later luxury automobiles. Most of Brewster's aircraft were constructed in this building, an old automobile factory in Long Island City. This was the only vertical aircraft factory in the world, which greatly hampered Brewster's production rate. All final assembly and flight testing was done at Roosevelt Field.

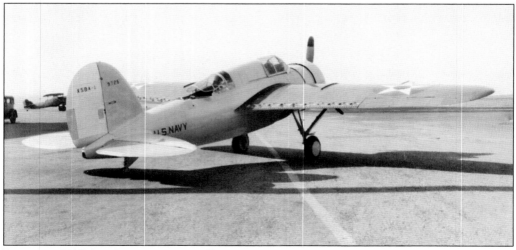

BREWSTER XSBA-1, PROTOTYPE DIVE BOMBER, ROOSEVELT FIELD, 1937. Brewster's first aircraft, the XSBA, was an advanced all-metal monoplane dive-bomber designed by Dayton T. Brown and built under a 1934 navy development contract. The navy was impressed with the design and purchased the production rights, building the aircraft at the Naval Aircraft Factory under the designation SBN-1.

U.S. NAVY BREWSTER SB2A BUCCANEER, C. 1942. The SB2A was a development of the SBA dive-bomber, showing the same layout as the earlier model but with a larger and more powerful 1750-horsepower Wright R-2600 engine. More than 300 were built for the U.S. Navy and British Royal Navy, although none saw combat service due to the aircraft's poor performance.

U.S. NAVY BREWSTER F2A-1 BUFFALO, 1939. The Brewster Buffalo was a fighter that saw limited service with the U.S. Navy during World War II. First flown in 1937, in 1939, the F2A became the first carrier-based monoplane fighter aircraft used by the U.S. Navy. However, in December 1941 and early 1942, it suffered severe losses in combat facing superior Japanese aircraft and was withdrawn from frontline service. They were powered by 950-horsepower Wright R-1820 engines.

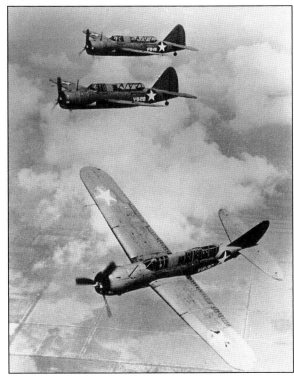

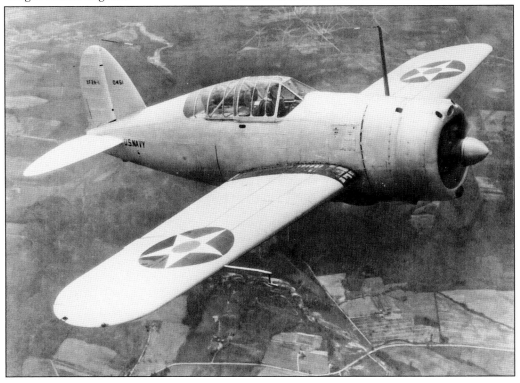

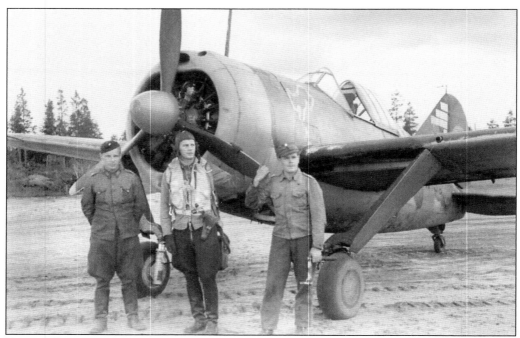

FINNISH BREWSTER B-239, 1942. In 1939, more than 50 of this model Brewster, essentially a de-navalized F2A-1, were sold to Finland for use in its ongoing war with Russia. Remarkably, the Brewster proved wildly successful in Finnish service, racking up an impressive 26-1 kill ratio against the Soviets and creating many Finnish aces. Other versions of the Buffalo were exported to England and Holland for service in the Far East.

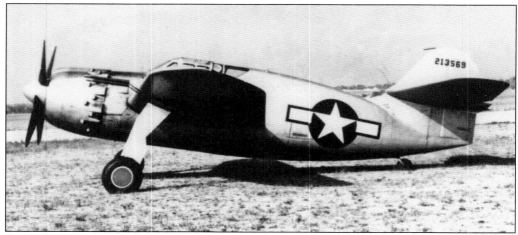

BREWSTER XA-32 BLASTER, 1943. Brewster's last design, the XA-32, was a dive-bomber/attack aircraft designed for the U.S. Army Air Corps. Ordered in 1941, production was delayed until 1943 due to Brewster's ongoing production trouble. Due to the delays, the U.S. Air Corps ultimately decided to modify P-51s for this mission. Thus, only two XA-32s were built, and they were powered by 2100-horsepower Pratt and Whitney R-2800 engines. Heavily armed, they could carry 3,000 pounds of bombs as well as six .50 caliber and four 20-millimeter guns. Due to lagging production and inferior products, the U.S. Navy took over control of Brewster in 1942, and the company ceased operation at the war's end.

BURNELLI-CARISI BIPLANE.
A two-place pusher biplane
powered by a 100-horsepower
Curtiss OX-3 engine, this
was the first aircraft built
by noted designer Vincent
Burnelli. Constructed in
Maspeth, Queens, with
assistance from John Carisi,
the novel design featured
side-by-side seating and swept-
back wings. Demonstrated
for the military in 1915,
only one was built, but it
provided Burnelli with his
first real experience in aircraft
design and construction.

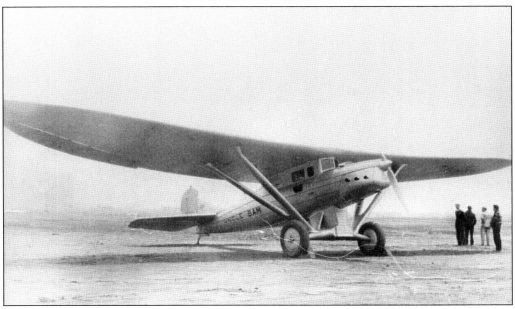

COLUMBIA AIR LINERS UNCLE SAM, ROOSEVELT FIELD, 1928. Columbia Air Liners was organized
by transatlantic flier Charles Levine in 1927. In a small factory in Long Island City, Queens, the
firm produced a total of three aircraft. The first aircraft was the Uncle Sam (seen here), a large,
all-metal monoplane powered by a 12-cylinder Packard engine. Designed as a long-range airliner,
it was based at Roosevelt Field for two years before being destroyed in a hangar fire.

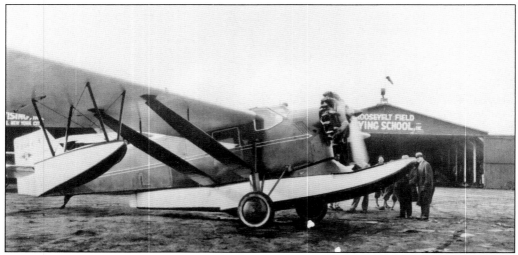

COLUMBIA AIR LINERS TRIAD, ROOSEVELT FIELD, 1929. Columbia's next two aircraft were Triads, Wright J-5 powered aircraft convertible for land or sea use. Designed to carry four passengers, the aircraft featured wheels for land use and a large removable central float for water operations. Although unique in design and successful in operation, no orders were forthcoming, and the company ceased operation in 1930.

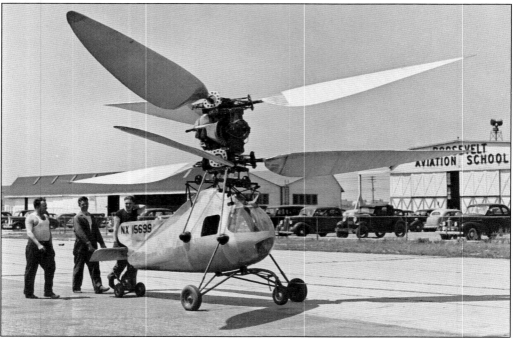

DEBOTHEZAT GB-5, ROOSEVELT FIELD, GARDEN CITY, 1941. Soviet émigré Georgi DeBothezat built a series of helicopters in the backyard of his Long Island City, Queens, home in the late 1930s and early 1940s. Under the name of the Helicopter Corporation of America, DeBothezat designed a fairly successful all-metal helicopter with two sets of counter-rotating blades, so no tail rotor was needed. The GB-2 and GB-5 were flown at Roosevelt Field on many occasions; however, the death of DeBothezat in 1942 brought development to a close.

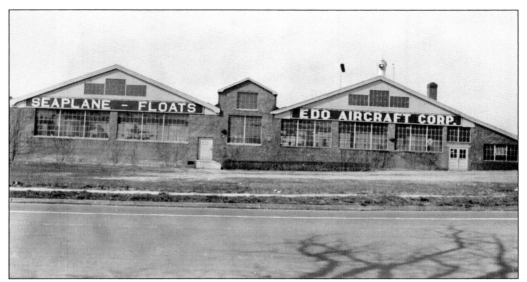

EDO Aircraft Factory, College Point, Queens, c. 1930. Founded by Earl D. Osborne in College Point in 1925, EDO became famous as the major manufacturer of a wide variety of aircraft floats. Earlier aircraft floats were wooden, but EDO developed a robust aluminum design that became the gold standard in aircraft floats from the mid-1920s through the 1940s. EDO survives today as a manufacturer of aircraft electronics, sonar systems, and ordnance delivery systems.

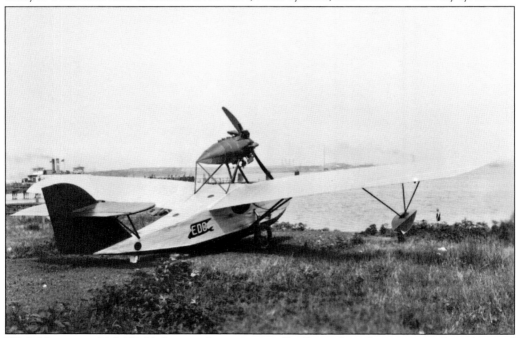

EDO Malolo, 1926. EDO's first airplane was a small, all-metal single-engine seaplane designed by Earl D. Osborne. In fact, this was the first all-metal lightplane built in America. Powered by an 110-horsepower engine, the aircraft did not live up to Osborne's expectations. He wisely realized that there was no market for low-powered seaplanes, but there was a huge market for all-metal aircraft floats that could be adapted to a wide variety of landplanes.

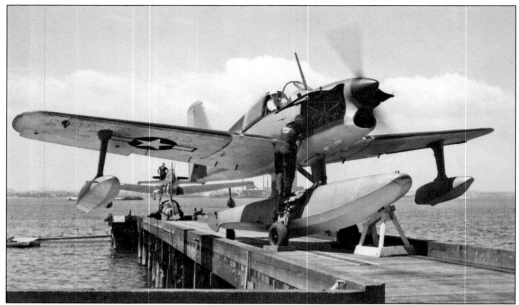

EDO XOSE, 1945. The only aircraft that ever reached limited production at EDO was the XOSE for the U.S. Navy during World War II. Powered by a Ranger V-12 engine, this was the last type of catapult-launched scoutplane ever built. However, World War II ended before the aircraft completed testing; thus a total of only seven were built.

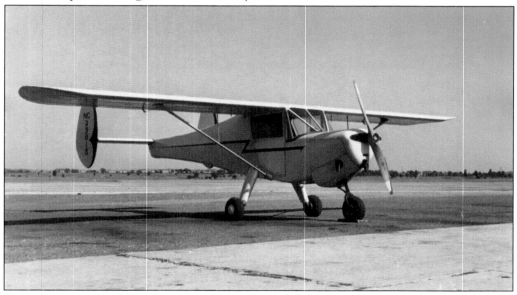

GENERAL AIRCRAFT G1-80 SKYFARER, 1940. General Aircraft, of Astoria, Queens, was founded in 1939 to produce the Skyfarer, a general aviation aircraft of unique design. The aircraft was designed as a foolproof, nonspinnable aircraft using only two controls instead of the usual three. There were no rudder pedals, and the twin vertical tails were fins only. Turns on the ground and in the air were made by turning the control wheel. By the end of 1941, General Aircraft produced 23 Skyfarers; however, the beginning of World War II brought civil aircraft production to a halt.

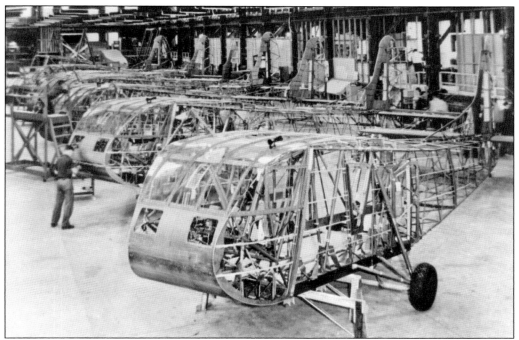

GENERAL AIRCRAFT CG-4 GLIDER PRODUCTION, 1944. During World War II, General Aircraft produced the welded steel fuselages for 1,112 Waco CG-4 troop gliders. These fuselages were then mated to the wooden wings and tails produced by Dade Brothers in Mineola. General Aircraft was unable to resume Skyfarer production in the overcrowded postwar general aviation market; thus it ceased operation in 1946.

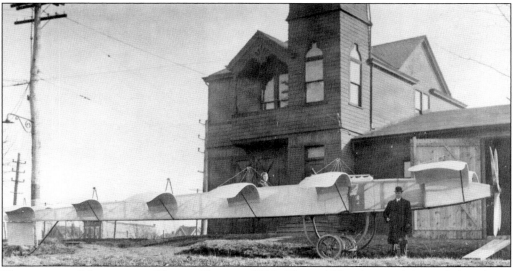

HUNTINGTON MULTIPLANE, HOLLIS, QUEENS, 1912. Howard Huntington (pictured above) was an early aeronautical experimenter born in Queens and briefly associated with Glenn Curtiss in 1908. In 1912, he built this large multiplane that was unable to achieve flight. Its gull-shaped wings were unique for their time and did offer some aerodynamic advantages. (Courtesy Queens Borough Public Library.)

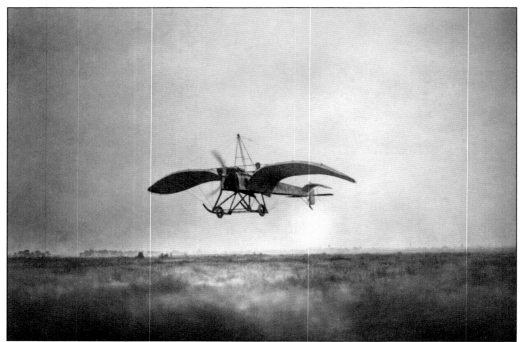

HUNTINGTON CLAM, 1914. Following a more traditional design, Huntington built this aircraft, apparently his second, which was flown several times at the Hempstead Plains Airfield in 1914. It proved that the gull-shaped wing was capable of supporting an aircraft in flight. This was the first of many gull-wing aircraft to be built during the past 100 years.

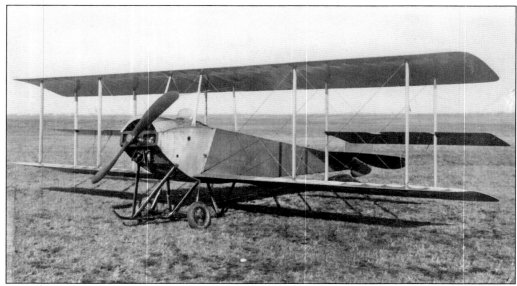

HUNTINGTON TRACTOR SCOUT, 1915. A two-place trainer built for an unsuccessful military evaluation, it was powered by a 90-horsepower Gyro engine. Built at the Hempstead Plains Airfield in Garden City, this was the last in the line of generally unsuccessful Howard Huntington aircraft. The mid-wing ailerons were unusual for a military aircraft. (Courtesy John Underwood.)

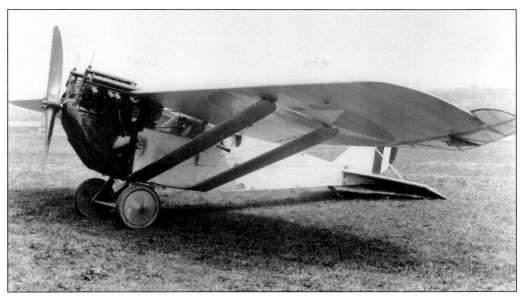

LOENING AERONAUTICAL ENGINEERING CORPORATION M-8, 1918. Founded by Grover Loening in 1917 and initially based in Long Island City, Queens, the Loening Company was responsible for a long and successful series of amphibious aircraft through the 1920s. The M-8 was a fast, powerful two-place fighter, the first monoplane fighter ordered by both the U.S. Army and U.S. Navy. Powered by a 300-horsepower Hispano-Suiza engine, an order for 5,000 was cancelled at the end of World War I; thus only two were built.

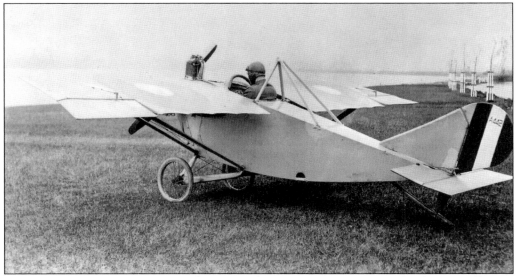

LOENING M-2 KITTEN, 1918. Another unusual Loening contract was to develop a small scout airplane—the Kitten—for the navy, which could be catapulted from submarines and would be able to operate as a landplane or floatplane. Powered by a 60-horsepower Lawrance L-2 engine, only two were built—one each tested by the army and navy. However, both services retained their interest in midget aircraft, which later resulted in contracts for other Long Island firms. The design was very much along the lines of the M-8, except in reduced scale. (Courtesy of John Underwood.)

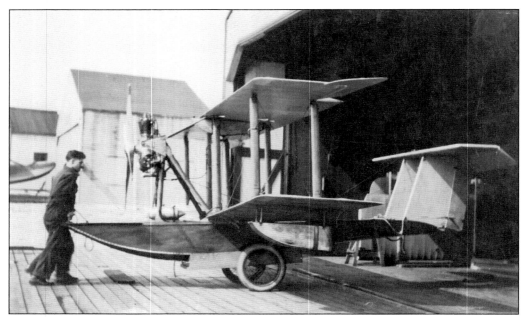

LOENING DUCKLING, C. 1919. Loening's first civil aircraft, the Duckling, was a low-cost seaplane powered by a 60-horsepower, three-cylinder Lawrance L-2 engine mounted on pylons in front of the cockpit. Only one was produced, but it featured twin tails, a feature incorporated in later Loening designs.

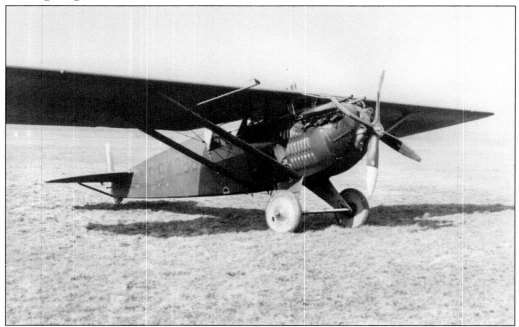

LOENING PW-2, C. 1921. Another monoplane fighter designed for the U.S. Air Service, the PW-2 (Pursuit Watercooled-2) was powered by a 300-horsepower Wright Hisso H engine. Essentially a more refined M-8 design, a total of four were built, but orders for more were cancelled after problems were found with wing structural integrity.

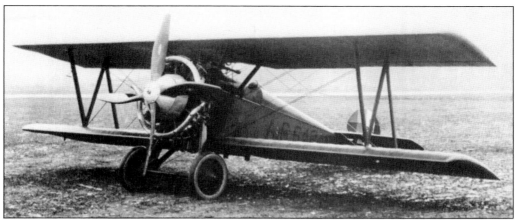

LOENING PA-1, 1922. Loening's PA-1 (Pursuit Aircooled-1) is noteworthy as being the first American fighter to fly with an air-cooled radial engine (350-horsepower Wright R-1). The aircraft's nose was very short in the interest of maneuverability. One was built by Loening and was tested by the U.S. Air Service at McCook Field in 1922. Armed with one machine gun, testing by the army did not deliver the desired speed, so the contract for a second was cancelled.

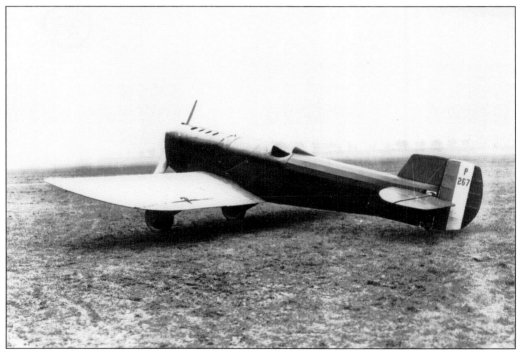

LOENING R-4 RACER, 1922. Loening's only aircraft specifically designed for racing, the R-4 was powered by a 600-horsepower Packard 1A engine. Designed in great haste, in spite of its beautiful streamlining, the R-4 suffered from control, vibration, and structural problems. Two were built for the army, but both performed poorly in the 1922 Pulitzer Trophy Race.

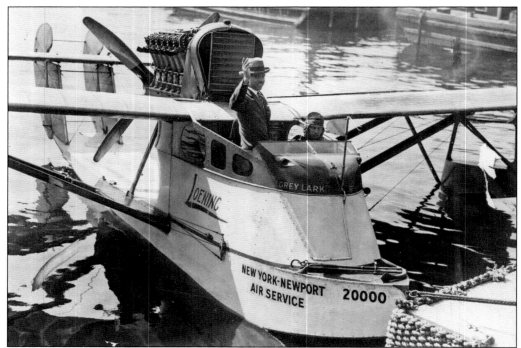

LOENING FLYING YACHT, 1923. This was a unique open-cockpit flying boat able to carry a pilot and four passengers. Powered by a 400-horsepower Liberty engine, the aircraft set both speed and altitude records for seaplanes. A total of 16 were built for both military and civilian use. Three were used as airliners between New York and Newport, Rhode Island, in 1923. Grover Loening is pictured above standing in the cockpit.

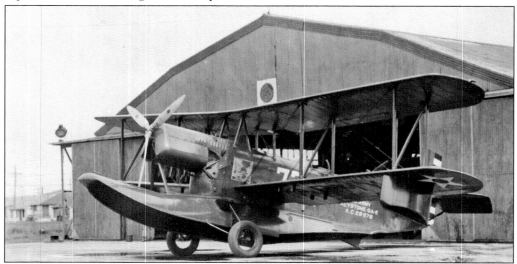

LOENING OA-1, 1925. Powered by an inverted 425-horsepower Liberty engine, this large single-float amphibian was a radical new design for its time. The fuselage and float were blended into a single unit. They were primarily designed for reconnaissance, mapping, and rescue work. Approximately 150 were built for both the army and navy in several different versions. Several of them made a notable flight around South America in 1926–1927.

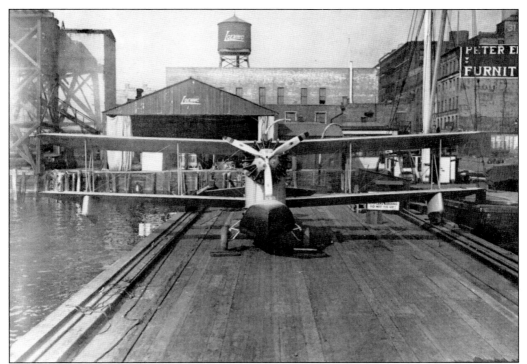

LOENING OL-8, 1928. A more advanced version of the OA-1, the OL-8 was powered by a 450-horsepower Pratt and Whitney R-1340 radial engine. Forty were produced for the navy as survey aircraft, primarily seeing use in Alaska, Hawaii, Central America, and the Philippines. This OL-8 is posed on the ramp in front of Loening's East River factory.

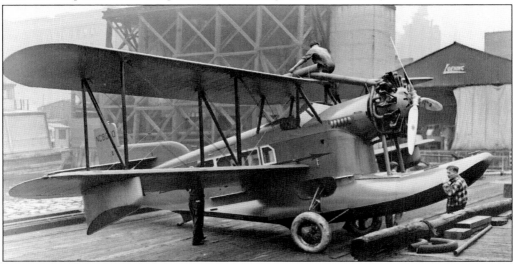

LOENING AIR YACHT, 1929. Building on the success of the military OL-8, Loening developed a civilian version, the Air Yacht, which was able to seat six people inside a widened fuselage. The Air Yacht was the first practical retractable landing gear amphibian, and it opened the first significant market for private seaplane aircraft. A total of 46 were built for wealthy individuals to use as commuters and for airline work.

LOENING **XSL-2, 1931.** A proposed naval scout amphibian, the aircraft featured folding wings so it could be stored aboard submarines. Powered by a 160-horsepower Menasco B-6 engine, only one was produced. However, the unique folding wing design was incorporated into later naval aircraft.

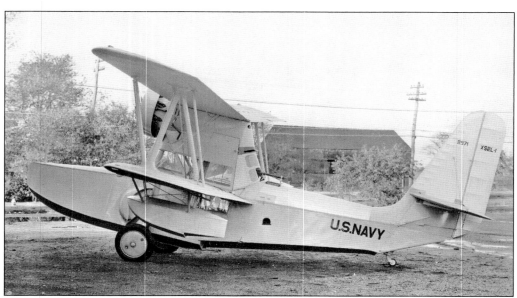

LOENING **XS2L-1, 1933.** This was a one-of-a-kind attempt to produce a more modern scout-observation airplane along the same amphibious lines. The Loening Company merged with Curtiss Wright in 1929, with Grover Loening then forming the Loening Aircraft Company, now based at Roosevelt Field, which produced experimental amphibious aircraft through 1936. As it was found unsuitable for carrier operations, this aircraft was never placed in production.

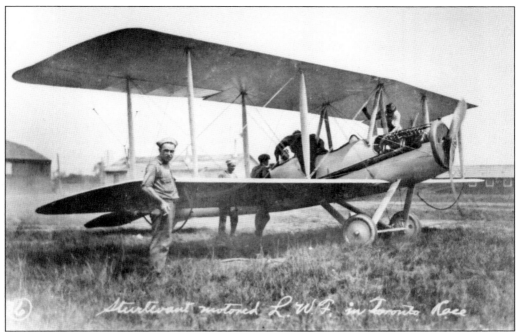

Sturtevant motored L.W.F. in Toronto Race

LWF Engineering Company Model V, 1918. Founded in 1915 by Edward Lowe, Charles Willard, and Robert Fowler, the firm LWF built aircraft with fuselages made of laminated wood construction. Constructed in College Point, Queens, the V was an army observation and training aircraft powered by a 140-horsepower Sturtevant engine. The V was the first American-built aircraft to see combat, with 24 serving on the Eastern front during World War I. A total of 135 were produced.

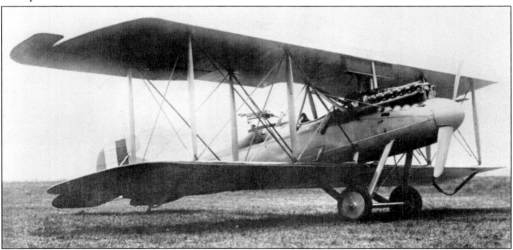

LWF Model G, 1918. LWF's Model G, built for military evaluation as an attack aircraft, was powered by a 400-horsepower Liberty 12 engine. It featured two forward firing machine guns, two more in the gunner's cockpit, and wing racks for four bombs. A well-designed and well-built aircraft, its performance exceeded that of the DH-4, then in use; however, it appeared too late to be of service in World War I. A total of three were built, with an army contract for many more cancelled at the time of the Armistice.

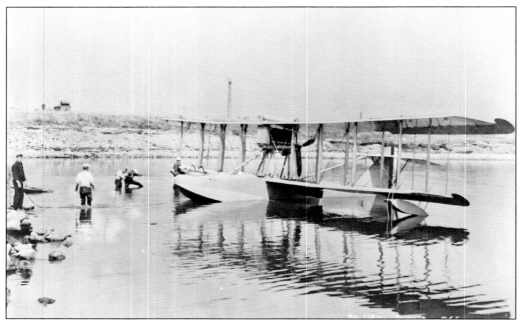

LWF HS-2L, COLLEGE POINT, 1918. LWF's most-produced aircraft, the HS-2L was a Curtiss-designed navy patrol flying boat. Powered by a 12-cylinder Liberty engine, HS-2Ls saw limited action as patrol aircraft at the end of World War I. LWF produced 305 HS-2Ls, which were largely built of wood and covered with fabric.

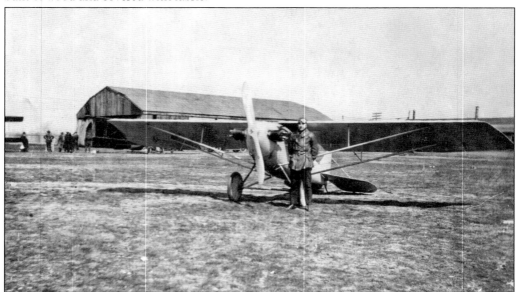

LWF MODEL L BUTTERFLY, 1919. One of the first light aircraft built in America for the civil market, the Butterfly was powered by a 72-horsepower, two-cylinder Cato engine. Designed by Joseph Cato, it was intended to be a cheap, easy-to-fly sportplane that could be enjoyed by a man of average means. Only one was built, and it did exhibit an eye-opening performance, including takeoff and landing runs of only 60 feet! The program came to an end when the prototype crashed, killing its pilot; production was halted.

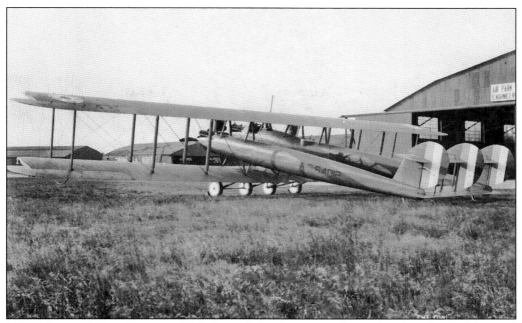

LWF Model H Owl, Bomber, 1920. Intended to be an army heavy bomber, the Owl featured a twin-boom fuselage of monocoque laminated wood construction and was powered by three 400-horsepower Liberty engines. The army funded the project but declined production. LWF tried to sell it to the post office as a long-range mail airplane; however, only one was produced.

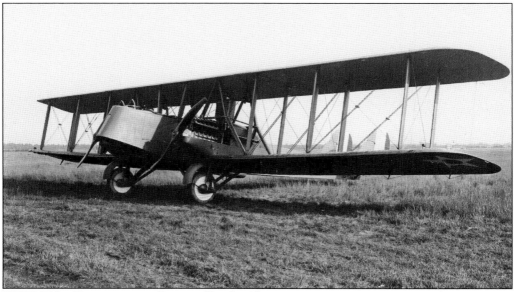

LWF NBS-1 Bomber, 1922. Designed by the Glenn L. Martin Company in 1918, the NBS-1 was an improved version of the original MB-1 design. Intended to be a night bomber, LWF underbid Martin on the production contract; thus it built 35 in 1921 and 1922. The standard army heavy bomber until 1928, the NBS-1 was powered by two 420-horsepower Liberty 12A engines. After the completion of this contract, LWF had no further prospects; thus the firm was forced into bankruptcy in 1923.

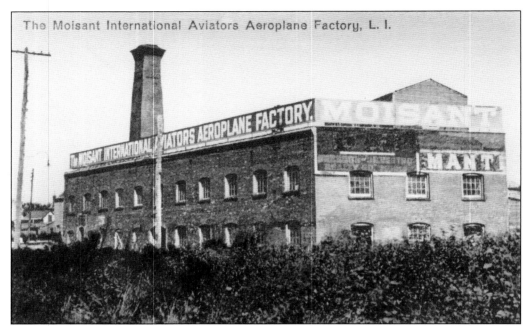

Moisant Aeroplane Company Factory, Winfield, Queens, c. 1913. Founded in 1911 by Alfred Moisant, Moisant basically built copies of French Bleriot and Morane-Saulnier monoplanes. Moisant ultimately produced about two dozen airplanes, but as they were unable to sell airplanes to the army during World War I, the company was forced into bankruptcy in 1916.

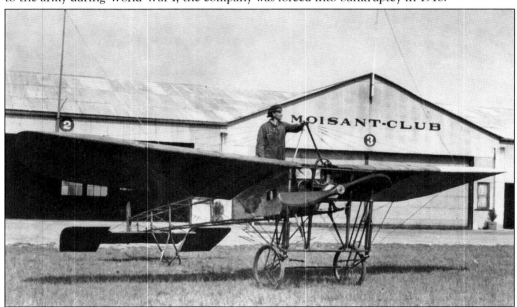

Moisant Bleriot, Hempstead Plains Airfield, Garden City, 1912. Almost a direct copy of the French Bleriot, the Moisant Bleriot was usually powered by a Gnome rotary engine. Several noted American aviators flew Moisant Bleriots, including Bernetta Miller, Mathilde Moisant, and St. Croix Johnstone, who set a new American speed record in one. This Moisant Bleriot is being used as a school machine at a Hempstead Plains flying school.

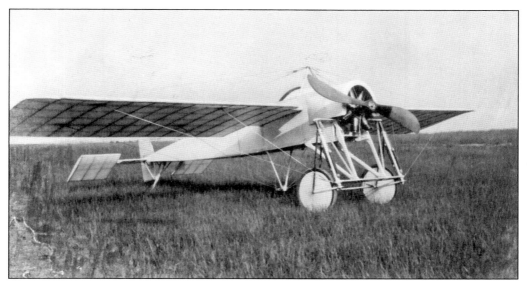

MOISANT BLUEBIRD, 1914. Essentially an American copy of a French Morane-Saulnier design, it was powered by a 50-horsepower Gnome rotary engine. Moisant produced about 12 of these monoplanes through 1915. In 1914, five were sold to the Mexican government for use in its civil war, where they saw action in 1915 and 1916 as reconnaissance scouts. Thus, these became the first Long Island–built aircraft to be purchased by an armed force and used in action, albeit unarmed. (Courtesy John Underwood.)

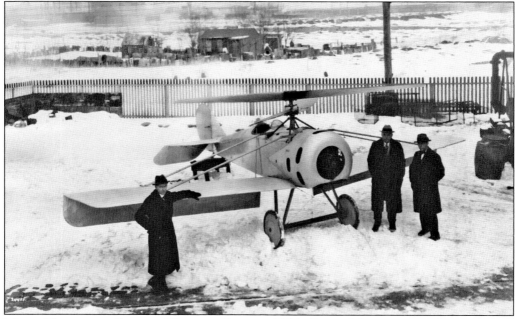

MYERS HELICOPTER, JACKSON HEIGHTS, QUEENS, 1926. George Myers was an aviation pioneer who began experimenting with helicopters in Ohio as early as 1904. Moving to Queens in 1920, he continued experimenting with vertical-flight aircraft. In 1926, he built this coaxial helicopter around the fuselage of a World War I Thomas Morse Scout fighter, powered by a 100-horsepower Gnome engine. It purportedly flew 1,000 feet at an altitude of 10 feet at Roosevelt Field in 1927.

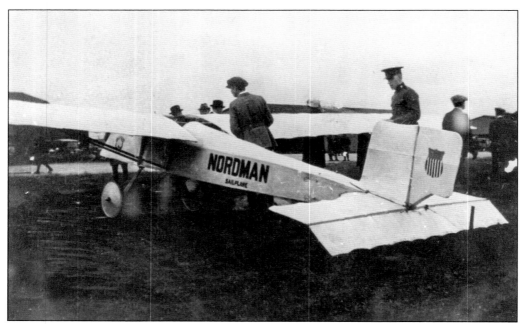

NORDMAN SAILPLANE, MITCHEL FIELD, 1923. Designed and built by Hans Nordman of Bayside, Queens, this lightly built glider weighed only 200 pounds. Towed aloft on a long rope attached to a motorcycle, the glider made many flights in Bayside. These flights attracted the attention of the military; thus the Nordman was demonstrated during a 1923 air show at Mitchel Field, again towed aloft behind a motorcycle.

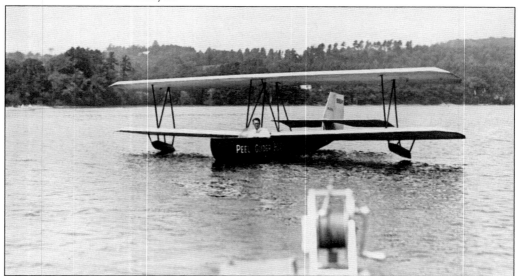

PEEL GLIDER BOAT CORPORATION, MODEL Z-1, 1929. Founded in College Point, Queens, in 1928, the Z-1, designed by Frederick Peel, was intended to be a simple, low cost glider in order to cash in on the flying fever sweeping the country after the Lindbergh flight of 1927. The Peel was the only American glider built with a boat hull and intended to be towed aloft behind a speedboat. The Peel was priced at $595. Featuring an aluminum hull and wooden wings (fabric covered), 30 Glider Boats were produced before the Depression forced the firm into bankruptcy in 1930.

CHANCE VOUGHT CORPORATION FACTORY, LONG ISLAND CITY, QUEENS, 1918. Vought was founded in 1917 by aviation pioneer Chance Vought primarily to produce aircraft for the U.S. Navy. Vought produced more than 200 aircraft in this Long Island City factory before moving to Connecticut in 1929. Aircraft off the assembly line had their engines tested in the street.

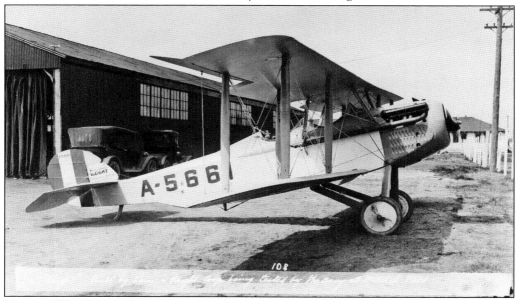

VOUGHT VE-7, HAZELHURST FIELD, GARDEN CITY, 1918. Powered by an 180-horsepower Hispano-Suiza engine, the VE-7 in 1922 became the first type of aircraft to operate off an American aircraft carrier (the USS *Langley*). Designed as a two-seat trainer, they were adopted by the navy as the first carrier-based fighter aircraft. A total of 149 were built for both the army and navy, mainly serving as advanced trainers.

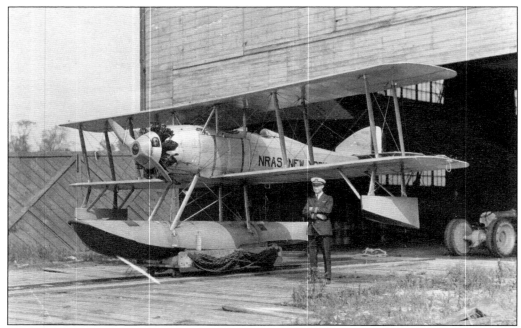

VOUGHT UO-1, 1922. Designed as a naval scout seaplane, the UO-1 could also be converted to a landplane. An observation aircraft, they were the only type of aircraft used aboard catapult-equipped U.S. Navy cruisers and battleships in the 1920s. They were powered by 200-horsepower Lawrence J-1 engines, the forerunner of the famous Wright Whirlwind engines.

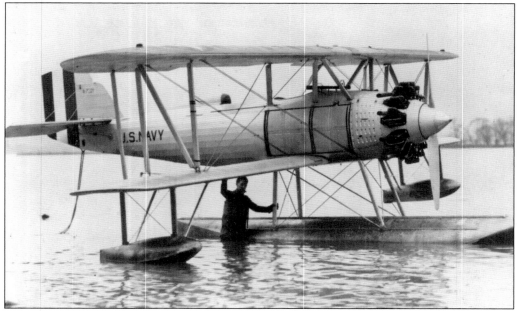

VOUGHT O2U-1 CORSAIR, 1926. Vought's most successful Long Island–built aircraft was the O2U Corsair, a two-seat scout/observation aircraft, which displayed performance equal to most single-engine fighters of the day. Available as both land and seaplanes, they were powered by 425-horsepower Pratt and Whitney engines. More than 150 were produced through 1929.

Three

NASSAU COUNTY

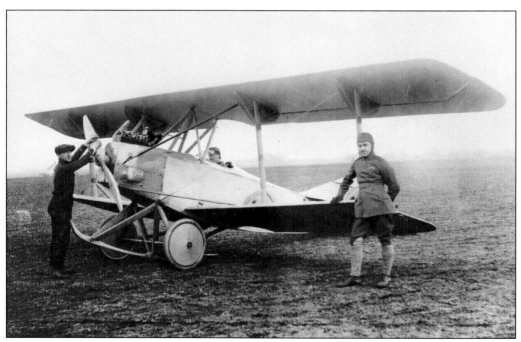

AIRCRAFT ENGINEERING CORPORATION ACE, 1918. Founded by Horace Keane, the only aircraft produced by the Aircraft Engineering Corporation (AEC) was the Ace, as seen here with one of its test pilots, ex-RAF pilot Bruce Eytinge (far right). This aircraft is noteworthy as being the first American sport airplane to be commercially produced following World War I. A total of seven appear to have been built between late 1918 and 1920 at Central Park (Bethpage) Flying Field. Keane in Queens also built its 40-horsepower water-cooled Acemotor. However, the aircraft was sold for $2,500, which was far above the cost of a war-surplus Jenny; thus no sales were forthcoming, and the firm quickly folded. (Courtesy John Underwood.)

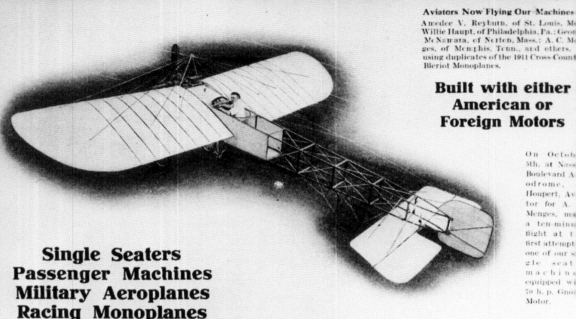

BLERIOT MONOPLANES

Aviators Now Flying Our Machines

Amedee V. Reyburn, of St. Louis, M.; Willie Haupt, of Philadelphia, Pa.; Geor. McNamara, of Norton, Mass.; A. C. Menges, of Memphis, Tenn., and others, using duplicates of the 1911 Cross-Country Bleriot Monoplanes.

Built with either American or Foreign Motors

On October 5th, at Nassau Boulevard Aerodrome, Houpert, Aviator for A. C. Menges, made a ten-minute flight at the first attempt on one of our single seat machines equipped with 70 h. p. Gnome Motor.

Single Seaters
Passenger Machines
Military Aeroplanes
Racing Monoplanes

For full particulars apply to

AMERICAN AEROPLANE SUPPLY HOUSE, 266-70 FRANKLIN ST., HEMPSTEAD, N. Y.

AMERICAN AEROPLANE SUPPLY HOUSE (AASH) ADVERTISEMENT, 1911. Opening in Hempstead in 1911, this was the first of many aircraft manufacturing companies to operate on Long Island. The AASH, founded by Frederick Hild and Edward Marshonet, basically built and sold copies of French Bleriot XI type monoplanes. Between 1911 and 1914, they produced three different models, with a variety of engines, all costing between $2,700 and $10,000.

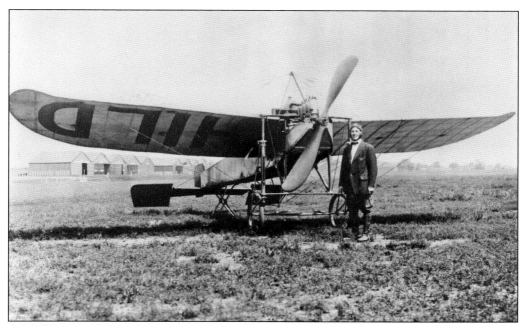

AASH Bleriot Single Seater, Nassau Boulevard Airfield, Garden City, 1911. This aircraft, sold as a training machine, differs from the French Bleriot in that the sides of the fuselage are covered with fabric, and an American 35-horsepower four-cylinder water-cooled Roberts engine powers it. It sold for $3,900.

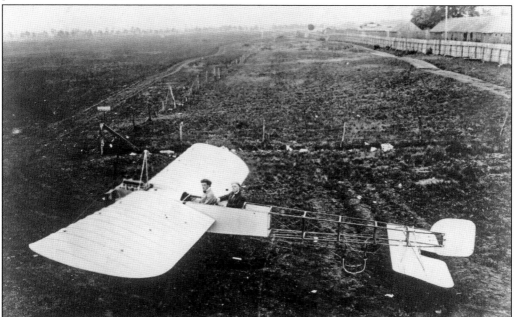

AASH Bleriot "Passenger Carrying Monoplane," Mineola Flying Field, 1911. This model was referred to as the "passenger carrying monoplane," as it seated two. In fact, this was the first successful two-place Bleriot built in the United States. It was usually powered by a 70-horsepower Gnome rotary engine, although this one clearly has a Roberts. They were sold for $5,500.

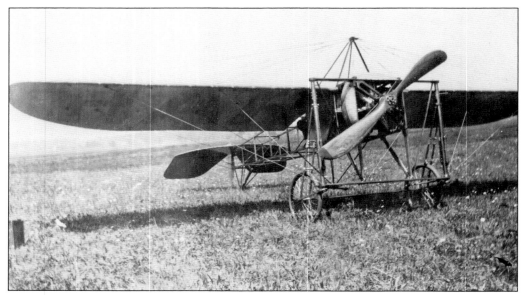

AASH Bleriot Racing Monoplane, c. 1911. Built for wealthy sportsmen to compete in air races, this model was powered by either a 100- or 140-horsepower Gnome rotary engine and cost between $8,400 and $10,000. AASH prided themselves on outstanding workmanship and the fact that the aircraft were copies "free from any radical or freakish ideas." However, during the firm's three years of operation, AASH appears to have sold only about 15 aircraft before ceasing operation in 1914.

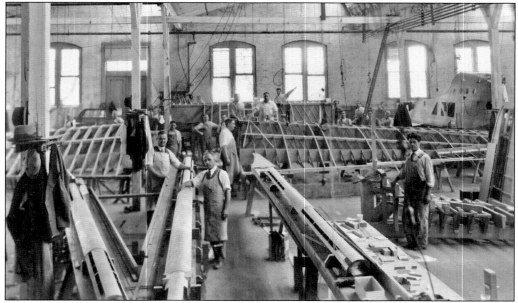

American Aeronautical Corporation (AAC) Factory Interior, Port Washington, 1929. American Aeronautical was established on the waterfront in Port Washington in 1928 in order to manufacture, under license, the well-known line of Italian Savoia-Marchetti flying boats and amphibians. This was the only Long Island aircraft company that built foreign designs. Here the wings of a S-55 flying boat are under construction.

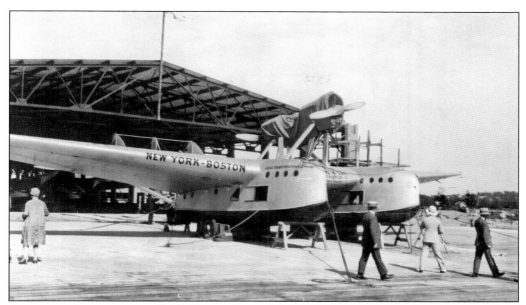

American Aeronautical S-55 Flying Boat, Manhasset Bay, Port Washington, 1930. This large 12-passenger twin-hull airliner was the only S-55 produced by AAC. The aircraft was powered by two Italian 500-horsepower Isotta-Frachini engines. For two years, the aircraft was operated as an airliner between New York and Boston.

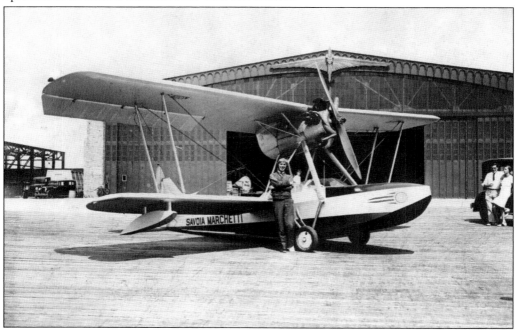

American Aeronautical S-56 Amphibian, on the Ramp in Front of the AAC Factory, Port Washington, 1930. Based on a World War I Italian seaplane design, the all-wood S-56 seated three and was powered by a 100-horsepower Kinner K-5 engine. A total of 36 were produced by AAC between 1929 and 1930. Their most notable use was when three were the first aircraft purchased by the New York City Police Department for surveillance and search and rescue work.

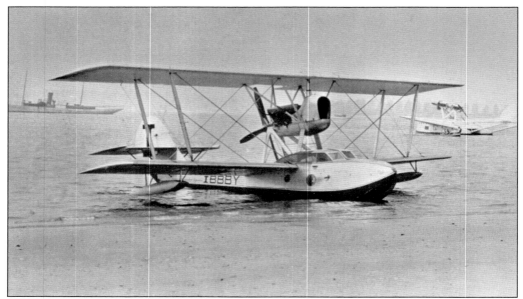

AMERICAN AERONAUTICAL S-62 AMPHIBIAN, MANHASSET BAY, C. 1930. Built for the civil market, the S-62 was able to carry seven people. Powered by a 500-horsepower Isotta-Frachini engine, only one was built by AAC in Port Washington. Due to slow sales during the Depression, AAC ceased operation in 1931. Its waterfront factory and hangar later becoming a seaplane base operated by Pan American Airways.

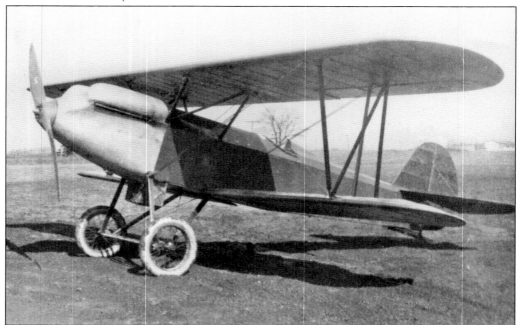

ASHLEY SP-5, ROOSEVELT FIELD, GARDEN CITY, C. 1929. Designed by Curtiss engineer David Ashley, the SP-5 was built in 1928 along the lines of a reduced-scale Curtiss Hawk fighter. Constructed at Roosevelt Field and powered by a 100-horsepower Curtiss OXX-6 engine, it was intended for the sportplane market, although only one was built, which remarkably is still flying as of 2010.

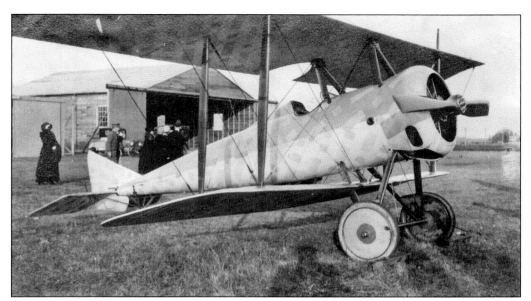

BERCKMANS AEROPLANE COMPANY SPEED SCOUT, CENTRAL PARK (BETHPAGE) FLYING FIELD, 1918. Maurice and Emile Berckmans designed an advanced (for its day) fighter at their small hangar at Central Park Flying Field. The aircraft was an unsuccessful entry into the U.S. Air Service competition for an advanced pursuit trainer. It was powered by a 100-horsepower Gnome rotary engine, and the fuselage was of a unique wooden monocoque design. Although demonstrating good speed and excellent maneuverability, none were ordered by the army, and the firm ceased operation at the end of World War I.

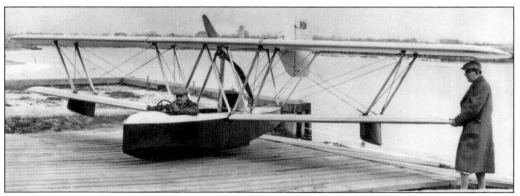

BOOTH BABY FLYING BOAT, FREEPORT, 1931. Designed and built by Harry Booth of Freeport, this tiny two-place flying boat was powered by a 32-horsepower Johnson outboard motor. The motor was placed in the bottom of the hull with a vertical shaft connecting it to the gearbox and propeller inset into the wing. Booth had hoped to sell plans for the airplane, which he claimed could be built for under $1,500, but it is unclear if any others were ever constructed. (Courtesy John Underwood.)

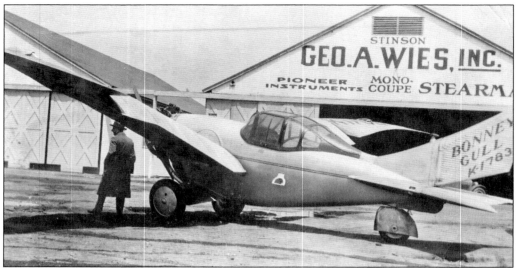

BONNEY GULL, ROOSEVELT FIELD, GARDEN CITY, 1928. Pioneer aviator Leonard Bonney dreamed of building an airplane with the grace and maneuverability of the seagull. After years of design, he built his airplane in Garden City in 1927. The aluminum aircraft was quite beautiful in appearance and unusually streamlined. The two-place, enclosed cockpit monoplane was also unique in that it had wings that could be adjusted in flight, in incidence, and the outer wing panels could sweep forward and aft. Powered by a nine-cylinder Kirkham engine, it also had a steerable tailwheel and brakes—all advanced features at the time. In 1928, Bonney attempted to fly the aircraft at Roosevelt Field. It rose quickly to about 100 feet and then nosedived into the ground, killing Bonney.

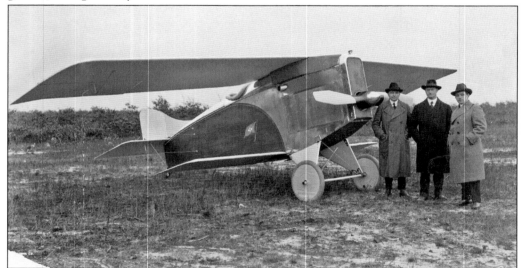

CANTILEVER AERO COMPANY CHRISTMAS BULLET, 1918. An unusual aircraft designed by Dr. William Christmas, the Bullet was built at Central Park (Bethpage) Flying Field. Constructed under a U.S. Air Service contract for a new type of fighter, the aircraft featured a flexible cantilevered upper wing, no supporting wing struts, and a warping elevator. This is the first model powered by an 185-horsepower Liberty Engine. A second version was powered by a Hall-Scott. Both aircraft suffered fatal crashes during testing; thus the project was abandoned.

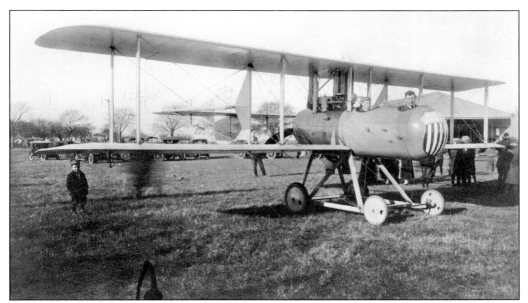

CONTINENTAL AIRCRAFT CORPORATION KB-1, 1918. Built at Central Park Flying Field, the KB-1 was designed by noted aircraft engineer Vincent Burnelli. Constructed under a U.S. Air Service contract for a new reconnaissance aircraft, the KB-1 was probably the best "pusher" design built in America at the time. However, its performance rendered it obsolete for military service, and its builders soon moved on to other projects.

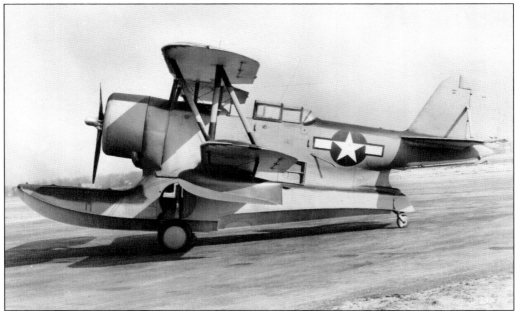

COLUMBIA AIRCRAFT CORPORATION J2F-6 DUCK, 1944. Columbia was established in 1943 at Curtiss Field in Valley Stream in order to produce the Grumman Duck amphibians for the navy. The Duck was a utility amphibian used as a navy reconnaissance, transport, and rescue aircraft throughout World War II and into the 1940s. Powered by a 1050-horsepower Wright Cyclone engine, Columbia built a total of 330 Ducks through 1945.

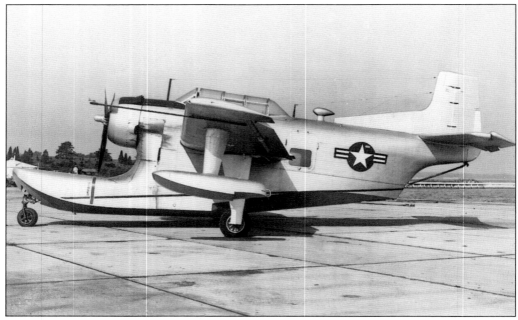

COLUMBIA XJL-1 AMPHIBIAN, 1945. Designed to replace the Duck as a utility amphibian in 1945, only two XJLs were produced. Although a well-engineered and well-built aircraft, the XJL was too late for World War II, and catapult-launched floatplanes were not needed in the postwar navy. Columbia ceased operation at the end of 1945, and its assets were sold to Commonwealth Aircraft.

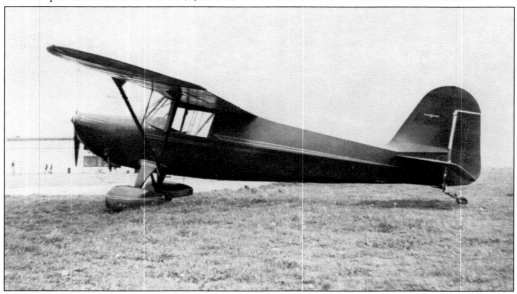

COMMONWEALTH AIRCRAFT, MODEL 185 SKYRANGER, 1946. Commonwealth Aircraft of Kansas City purchased the Columbia Aircraft Corporation of Valley Stream in 1945 and soon began the production of the Model 185 Skyranger there. The Skyranger carried two people and was powered by an 85-horsepower Continental engine. A civil lightplane, Commonwealth built 276 Skyrangers before it was forced to cease operation in 1947 due to limited sales in the competitive postwar civil aircraft market.

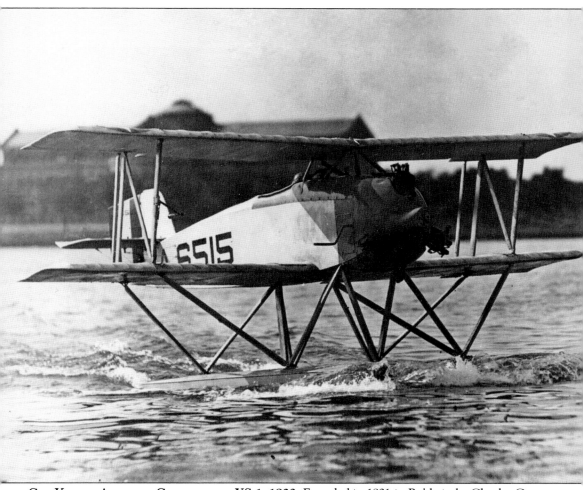

COX KLEMIN AIRCRAFT CORPORATION XS-1, 1923. Founded in 1921 in Baldwin by Charles Cox and noted aerodynamicist Alexander Klemin, this firm existed for five years and mainly focused on experimental work for the military. The tiny XS-1 seaplane, seen here, was designed as a naval scoutplane and was the first aircraft ever catapulted from an American submarine.

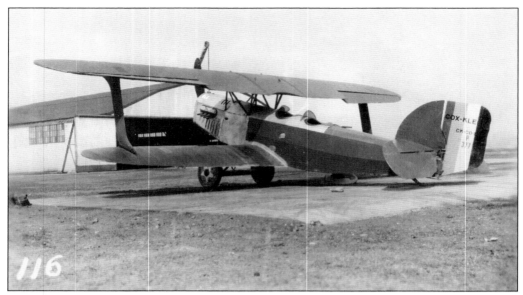

COX KLEMIN XO-4 OBSERVATION PLANE, 1924. An experimental reconnaissance airplane for the U.S. Army, a total of two were built and tested at McCook Field. It was claimed the aircraft had a top speed of 135 miles per hour and a service ceiling of more than 20,000 feet. Powered by a 470-horsepower Napier Lion engine, tests by the U.S. Air Service proved disappointing, and it was found to be unsuitable for military service.

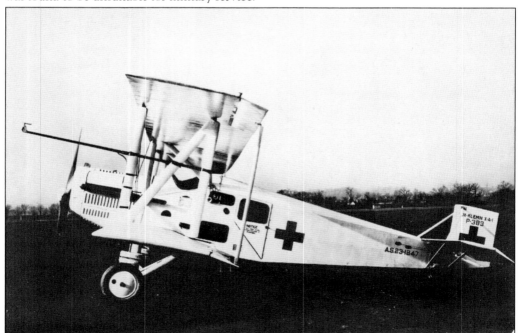

COX KLEMIN XA-1 AERIAL AMBULANCE, 1924. The XA-1 is noteworthy as being the first American aircraft specifically designed as a flying ambulance for the U.S. Army Air Service. It was powered by a 420-horsepower Liberty 12 engine, and inside were accommodations for two stretchers. Apparently only two were built, with at least one being assigned to the Panama Canal Zone.

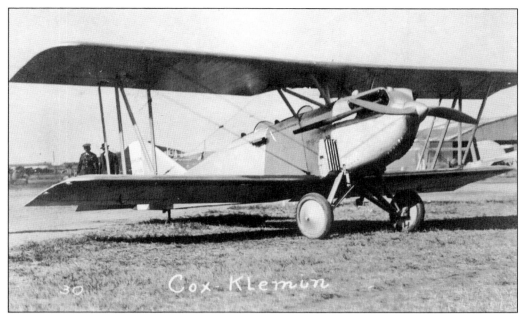

COX KLEMIN CK-2 TRAINING PLANE, 1925. Built for the 1924 U.S. Army Air Service observation airplane competition, the CK-2 was powered by a 400-horsepower Liberty engine. Two were built and were evaluated by the army for observation planes at Wright Field. Both aircraft were rejected and returned to the company. Unusually they featured interchangeable upper and lower wings.

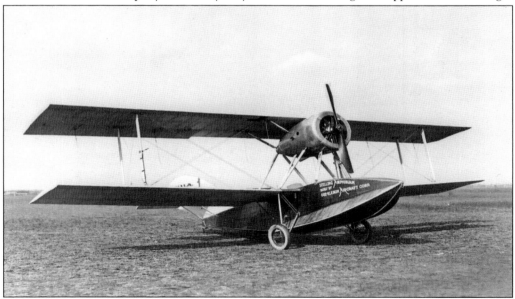

COX KLEMIN CK-18 NUNGESSER AMPHIBIAN, 1925. Designed by Capt. Charles Nungesser, the CK-18 was built by Cox Klemin and was distributed through automobile dealer John Stelling. The aircraft carried three people and was powered by a 135-horsepower rotary engine. Due to the lack of orders, the firm ceased operations in 1926, with Klemin becoming the director of the Guggenheim School of Aeronautics at New York University. Cox Klemin's Baldwin factory later became the first factory of the Grumman Aircraft Corporation. (Courtesy John Underwood.)

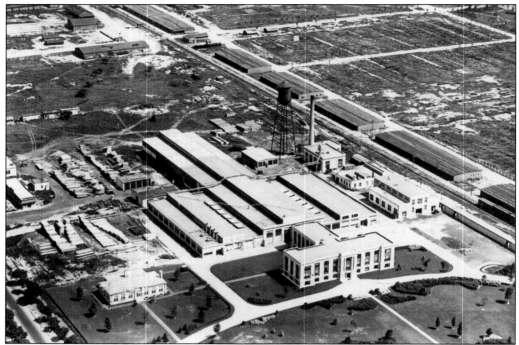

CURTISS AEROPLANE AND MOTOR CORPORATION FACTORY, GARDEN CITY, C. 1925. Pioneer aviator Glenn Curtiss established a new factory in Garden City in 1917 adjacent to Roosevelt Field for the research and development of new types of aircraft. It was the world's only aircraft research and development factory, and many historic, new types of Curtiss aircraft were designed and built here through the 1920s.

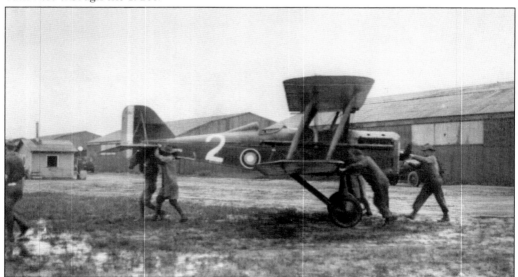

CURTISS SE-5, MITCHEL FIELD, 1918. A leading British World War I fighter, the SE-5 was chosen for mass production in the United States. Curtiss was given an order for 1,000; however, only one example was built in Garden City, and another 56 British-built airframes were sent to Curtiss for assembly. They served in the U.S. Air Service as advanced trainers until 1927.

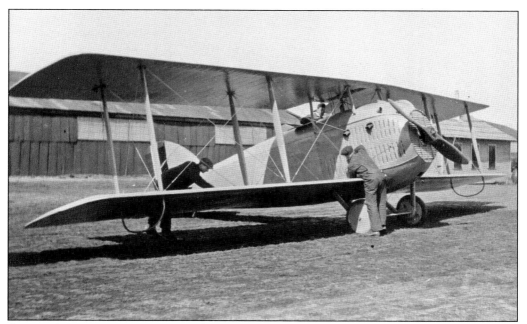

CURTISS MODEL 16, HA-1, 1918. Three of these scout/fighter airplanes were built for the U.S. Navy in 1918 and 1919 and were operated as floatplanes. Three additional landplane versions were built, seen here, and were operated by the U.S. Post Office as mailplanes in 1919. All versions were powered by 360-horsepower Liberty engines.

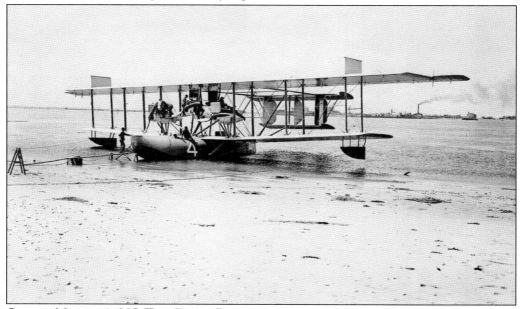

CURTISS MODEL 12, NC TYPE FLYING BOAT, 1918. Designed for antisubmarine patrol, as well as transatlantic flight, in 1918, Curtiss built 10 of these huge flying boats for the U.S. Navy. In May 1919, the NC-4, seen here, became the first aircraft to fly the Atlantic Ocean between New York and Europe. The aircraft had a crew of five and was powered by three 400-horsepower Liberty engines.

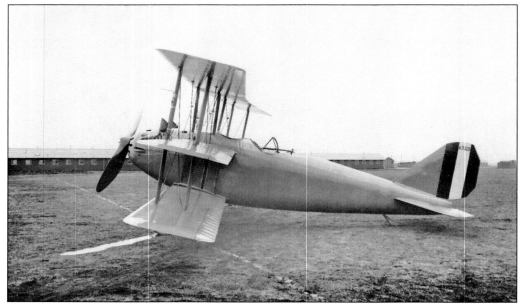

CURTISS MODEL 15, 18T WASP, 1918. This was one of three two-seat triplane fighters built for both the army and navy to test in 1918. Powered by a 400-horsepower Curtiss Kirkham K-12 engine, they were also able to be equipped with floats. Although triplanes, these were among the fastest airplanes in the world in 1919. In 1919, Curtiss test pilot Roland Rholfs set a new world altitude record in one of the planes, reaching a remarkable 34,910 feet.

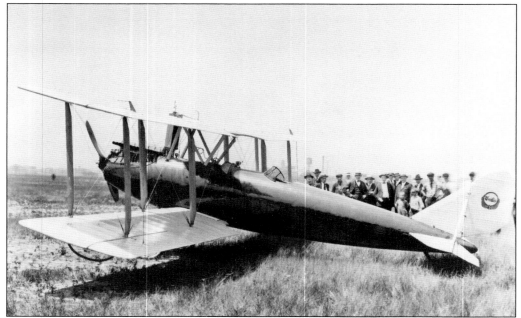

CURTISS MODEL 17, ORIOLE, 1919. Powered by a 160-horsepower Curtiss C-6 engine, the Oriole was designed as a three-place sportplane. The fuselage was of a unique wooden monocoque construction. Several saw success as racers in the early 1920s. Due to the glut of cheap war-surplus Jennies, the aircraft's sales were far less than hoped for, and it saw limited production.

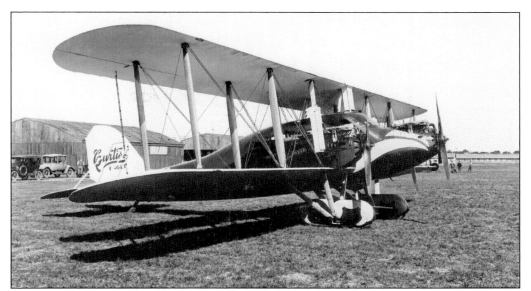

CURTISS MODEL 19, EAGLE, CURTISS FIELD, 1919. An eight-passenger, tri-motored airliner, a total of five Eagles were built. Powered by three 160-horsepower Curtiss C-6 engines, the Eagle featured a properly designed passenger cabin with an enclosed cockpit. This was an attempt to produce an airliner for the anticipated postwar aviation boom that failed to materialize. Three were operated by the U.S. Air Service as transport and ambulance aircraft.

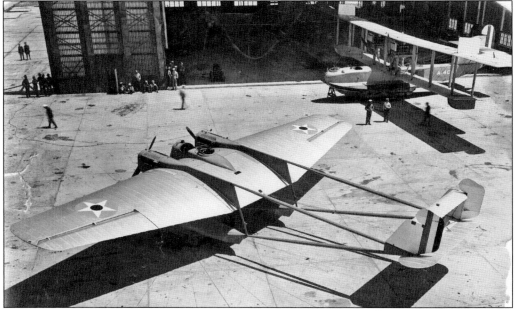

CURTISS MODEL 24, CT TORPEDO PLANE, ROCKAWAY NAVAL AIR STATION, 1921. This unconventional aircraft was built as a torpedo bomber for the U.S. Navy. Powered by two 435-horsepower Curtiss D-12 engines, the only CT built was tested at the Rockaway Naval Air Station on Long Island in 1921. The crew sat in a central pod with engine nacelles built into the wooden cantilevered wing with the tail surfaces supported by booms connected to the twin floats and wing.

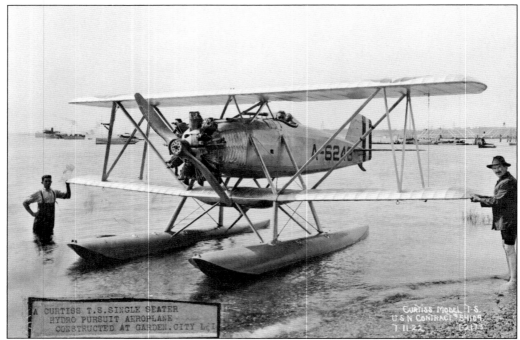

CURTISS MODEL 28, TS-1, 1922. An all-wood naval fighter, the TS was built in both landplane and seaplane versions. The U.S. Navy's first carrier-based fighter, 34 were built for use on the USS *Langley*, the navy's first aircraft carrier. The centrally placed fuselage between the wings was unusual, and the aircraft was the first U.S. naval fighter powered by an air-cooled radial engine, the 200-horsepower Lawrence J-1.

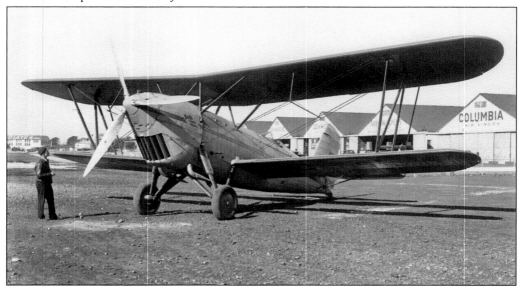

CURTISS MODEL 40, CARRIER PIGEON II, ROOSEVELT FIELD, 1929. Designed as a mailplane, three were built for National Air Transport in 1929. This was an improved version of the first Carrier Pigeon, built for the post office in 1925. It was powered by a 600-horsepower Curtiss Conqueror engine. The pilot sat toward the rear with a large mail compartment in the front.

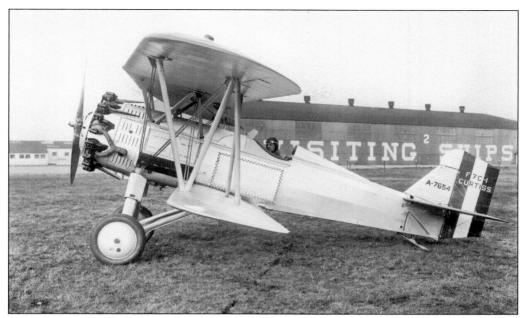

CURTISS MODEL 43, F7C SEAHAWK, 1927. Designed for the 1927 navy fighter competition, and based on the U.S. Army Hawk fighter, 17 were eventually built for the U.S. Marines. It was powered by a 450-horsepower R-1340 Wasp engine. Although developed as a seaplane fighter, it was only operated as a landplane by the marines.

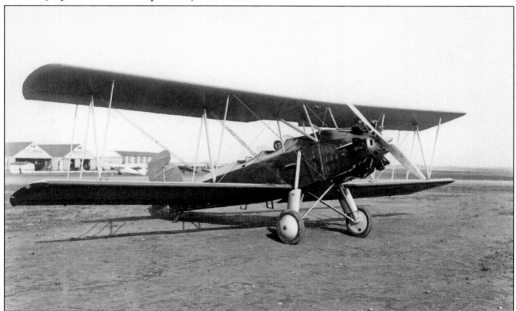

CURTISS MODEL 48, FLEDGLING, 1927. Intended to replace Curtiss's famous Jenny basic trainer, a total of 160 were built as both military and civilian training planes. The Fledgling was not only larger and less versatile then competing models, but the onset of the Depression wiped out the market for all civil biplane trainers. It was powered by either a Wright J-6 or Curtiss Challenger engine.

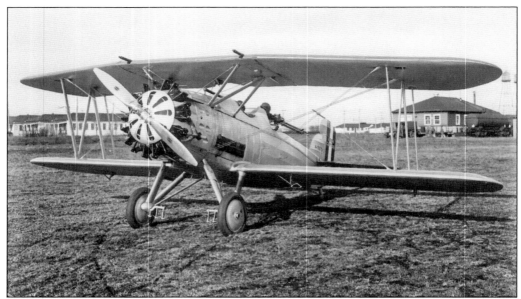

CURTISS MODEL 49, F8C HELLDIVER, 1928. A two-seat navy scoutplane/divebomber, more than 150 were built in several models. Other than Hawks and Falcons, this was the principal Curtiss military product of the late 1920s. This was also the first production navy aircraft designed principally for dive-bombing. It was powered by a 450-horsepower Pratt and Whitney R-1340 engine.

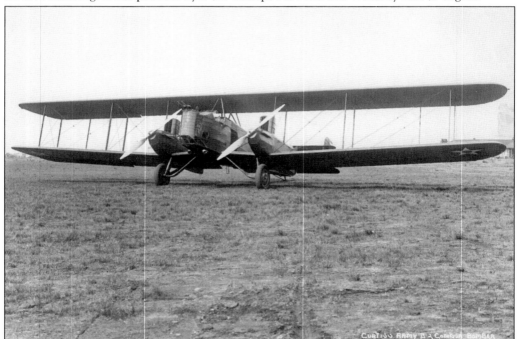

CURTISS MODEL 52, CONDOR B-2 BOMBER, 1928. The 13 B-2 Condors built by Curtiss formed the entire U.S. heavy bomber force from 1929 until the early 1930s. A large biplane bomber, the Condor was powered by two 600-horsepower Curtiss Conqueror engines, and it carried a crew of five. Cruising speed was a leisurely 105 miles per hour.

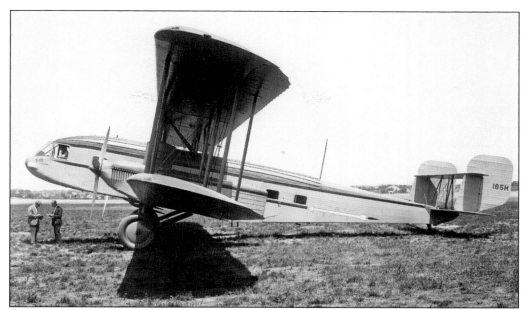

CURTISS MODEL 53, CONDOR AIRLINER, 1929. A redesigned B-2 Condor bomber, the civil Condor was a fabric-covered, 18-seat airliner. Six Condors were built at Garden City. All were sold to Eastern Air Transport, later Eastern Airlines. Unfortunately, the civil Condor had little appeal to the airlines, most of which were then using the well-established Ford and Fokker trimotor monoplanes.

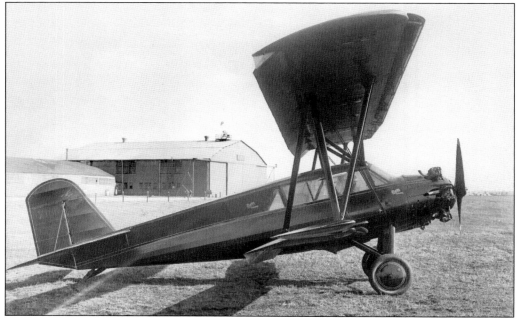

CURTISS MODEL 54, TANAGER, 1929. Designed as a one-of-a-kind experimental aircraft just to demonstrate new flight safety devices, the Tanager won the 1929 Guggenheim Safe Aircraft competition at Mitchel Field. This was one of the first aircraft to use leading edge slots and trailing edge wing flaps in order to achieve true low-speed controllability.

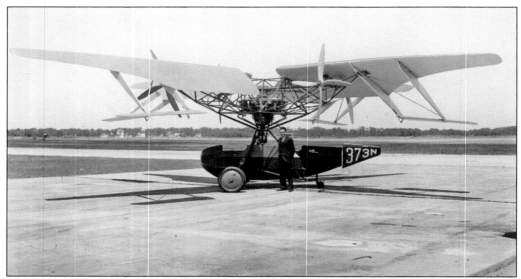

CURTISS-BLEECKER HELICOPTER, ROOSEVELT FIELD, 1929. Designed by Maitland Bleecker and built by Curtiss in Garden City, this was another pioneer helicopter that attempted to solve the problem of vertical flight. It consisted of four propellers mounted to four rotary wings driven by a central 420-horsepower Pratt and Whitney engine. A small fuselage was slung underneath, and four movable surfaces attached to the wings were an attempt at control. The helicopter is reputed to have made several "hops," but the project was abandoned due to the lack of stability.

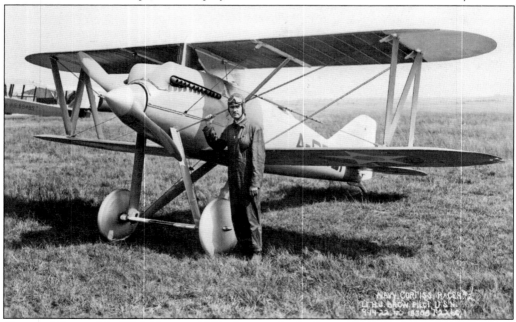

CURTISS MODEL 23, CR-2 RACER, 1921. Curtiss also built a series of highly successful racing aircraft for both the army and navy through the 1920s. This aircraft, ordered by the navy, won the 1921 Pulitzer Trophy speed race. All built in Garden City, the Curtiss racers were the fastest airplanes in the world throughout the 1920s. This one was powered by a 425-horsepower Curtiss CD-12 engine.

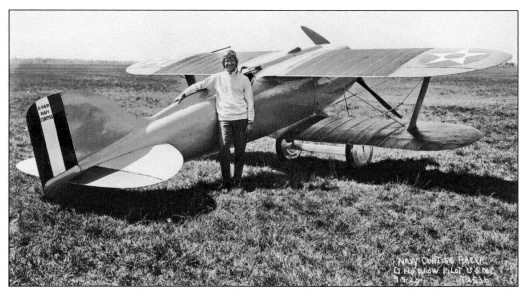

CURTISS MODEL 32, R2C RACER, 1923. The navy bought two new racers from Curtiss in order to compete against the army for the 1923 air race season. The R2C's featured radiators on the upper wing surfaces, for greater streamlining, and were powered by 500-horsepower Curtiss D-12 engines. Navy Lt. H. J. Brow, seen here, set a world speed record in this aircraft at 259 miles per hour in November 1923.

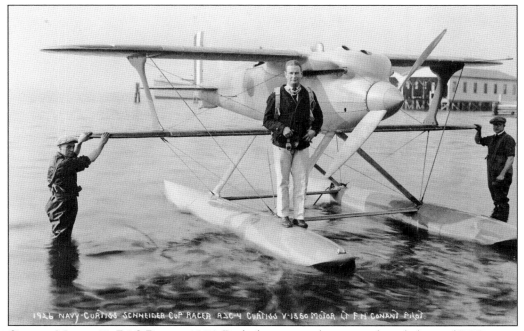

CURTISS MODEL 42, R3C RACER, 1925. Both the army and navy purchased identical R3C racers from Curtiss for the 1925 air race season. Here Lieutenant Conant (center) poses with the navy racer flown in the 1925 Schneider Trophy seaplane races. The army landplane version of the R3C won the 1925 Pulitzer Trophy race with Lt. James Doolittle piloting. All were powered by 565-horsepower Curtiss V-1400 engines.

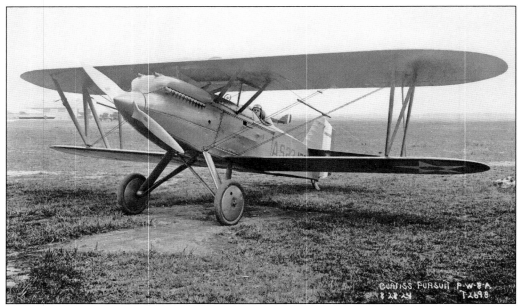

CURTISS MODEL 33, PW-8 FIGHTER, 1924. The first of the famous line of U.S. Army Hawk fighters, the PW-8 (Pursuit Watercooled-8) was initially produced in a batch of 25. The aircraft featured a metal fuselage, wooden wings, and was powered by a 435-horsepower Curtiss D-12 engine. The last PW-8 built was modified with tapered wings and a tunnel-type radiator under the nose, and it served as the prototype for all later Hawk models.

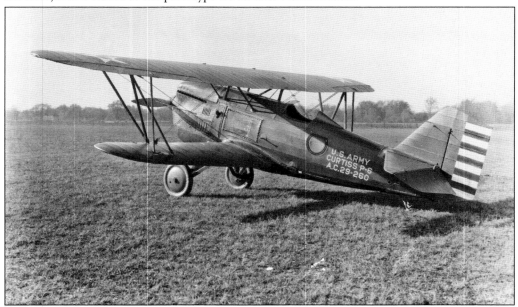

CURTISS MODEL 35, P-6 HAWK, 1927. A speedy fighter, the Hawk was Curtiss's most produced military aircraft of the 1920s and 1930s. In production between 1925 and 1931, a total of 656 were built in 17 different models, with 273 going to the army, 132 to the navy, and 251 for the commercial and export market. Most were powered by 600-horsepower Curtiss Conqueror engines. The most prevalent army fighter of the late 1920s, many remained in service as late as 1937.

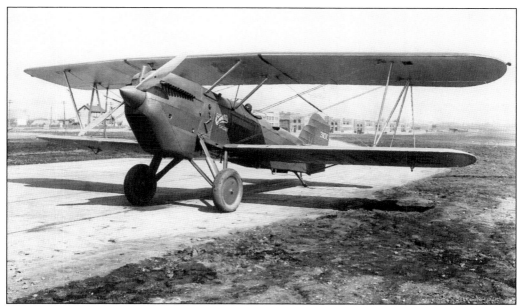

CURTISS MODEL 37, O-1 FALCON, 1927. A popular army two-place reconnaissance aircraft, more than 220 Falcons were built through 1933, although the aircraft was first designed in 1923. The navy also used many Falcons as trainers and personnel transports. The Falcon was produced in 11 different models, using six different engines. The aircraft carried three machine guns, and bomb racks could be fitted under the wings.

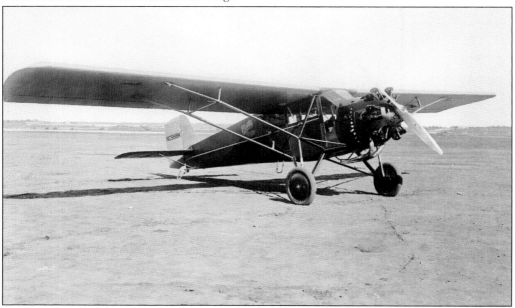

CURTISS MODEL 50, ROBIN, 1929. The Curtiss Robin was the most popular civil aircraft of the late 1920s and early 1930s. It was a three-seat cabin monoplane first equipped with a Curtiss OX-5 engine and later a Curtiss Challenger. A total of 769 were built for the personal airplane market. The aircraft featured a welded steel tube fuselage and wooden wings; both were fabric covered. This was the most produced Curtiss airplane between the two World Wars.

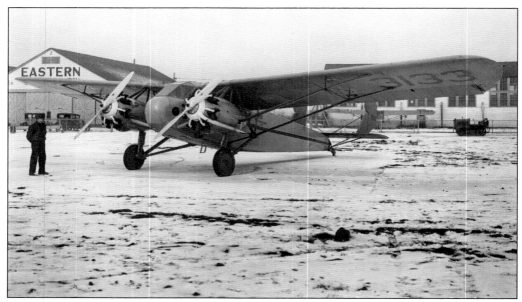

CURTISS MODEL 55, KINGBIRD, 1929. This twin-engine, eight-passenger monoplane was one of 21 built as a small airliner. A unique design feature was the close placement of the engines and propellers ahead of a short nose in order to minimize engine-out control problems. However, the timing of the Kingbird was poor, with the Depression eliminating any possibility of major sales.

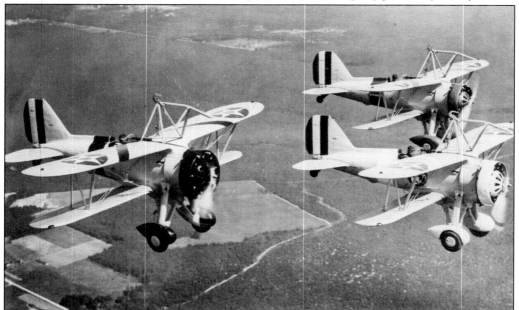

CURTISS MODEL 58, F9C SPARROWHAWK, 1930. One of the most unique aircraft ever built, the F9C was a naval scoutplane/fighter designed for use aboard the U.S. Navy dirigibles *Akron* and *Macon*. Note the hook on top of the fuselage used to catch the airship's lowered trapeze. A total of eight were built. Due to slow sales during the Depression, Curtiss was forced to consolidate its operations; thus it closed the Garden City plant, moving all research and development functions to Buffalo.

DADE BROTHERS FACTORY INTERIOR, MINEOLA, 1944. Prior to World War II, Dade Brothers (founded by George and Robert Dade) was located adjacent to Roosevelt Field and was primarily a housebuilder. When the U.S. Army awarded contracts for the production of CG-4 troop gliders, Steinway and Sons, the piano makers in Queens, originally received the contract to build the wooden wings and tails. However, Steinway's rate of production was too slow for the army (their workmen were too meticulous!); the contract was pulled and awarded to Dade. The army preferred the speed of a housebuilder to fine craftsmanship.

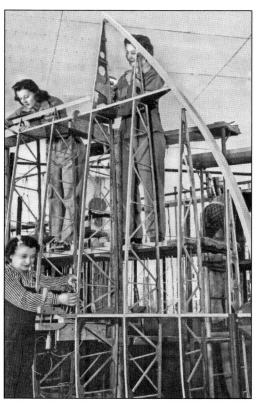

CG-4 TROOP GLIDER BEING SHIPPED FROM DADE BROTHERS, 1944. By 1945, Dade produced nearly 1,000 of the huge wooden wings and tail assemblies to match the steel tube fuselages built by General Aircraft in Queens. Dade was then responsible for fitting together the entire glider and crating it for shipment overseas. Designed by Waco, the CG-4 was the most widely used troop/cargo glider of World War II. Almost 15,000 were built by 17 different companies.

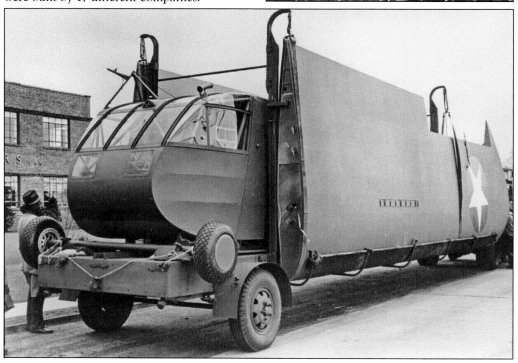

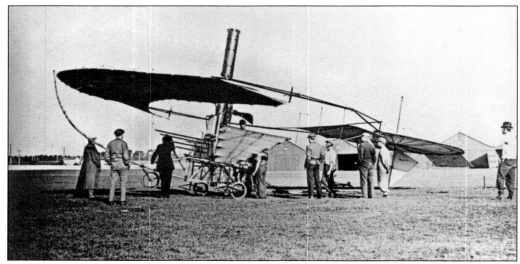

DIETZ-EASON UMBRELLAPLANE, MINEOLA, 1910. Designed by Stephen Eason and built at the Mineola Flying Field in 1910, the Umbrellaplane consisted of a circular wing monoplane with the pilot, engine, and landing gear in the open center. Supposedly an emergency parachute was contained inside the vertical tube. Purportedly flown on Long Island in 1911, Eason soon moved to Chicago, where he continued experimenting with his unique design through 1913.

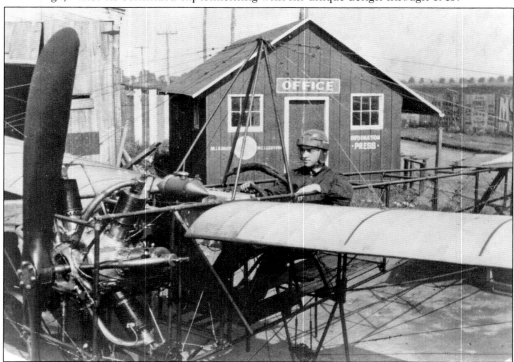

FAIRCHILD (WALTER) MONOPLANE, MINEOLA, 1911. Designed and built by Walter Fairchild (pictured here) at Mineola Flying Field (no relation to Sherman), this monoplane was powered by a Christie "6" radial engine. It was a unique design for its day, resembling a Bleriot, but featuring all-metal construction (fabric covered) and tapered wings. (Courtesy John Underwood.)

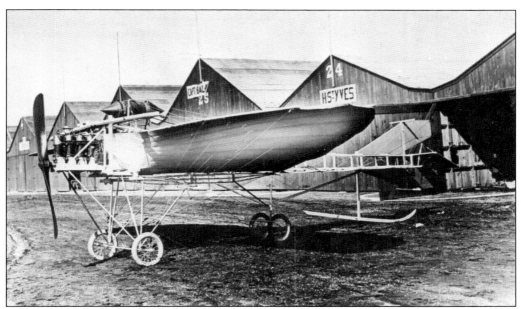

FITY MONOPLANE, MINEOLA, 1910. Designed and built by Charles Fity at Mineola, this unusual airplane featured folding wings and rear wheels that were steerable and turned with the rudder so the aircraft could be driven on the ground. Powered by an inline marine engine, Fity claims to have flown the aircraft three times, but these reports cannot be verified. Apparently this was the first attempt at producing a roadable aircraft in the United States.

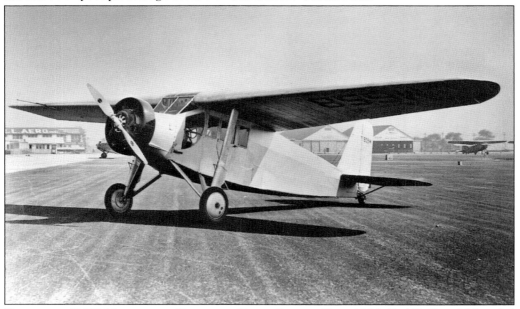

FLEETWINGS F-101 MONOPLANE, ROOSEVELT FIELD, GARDEN CITY, 1930. Carl DeGanahl founded Fleetwings in 1929 at Roosevelt Field for the construction of a new type of aircraft. Believing wooden wings had their limitations, DeGanahl built the F-101, a high-wing monoplane, seen here, with wings of spot-welded stainless steel. This aircraft was only built for research and development into this new type of construction, so only one was produced.

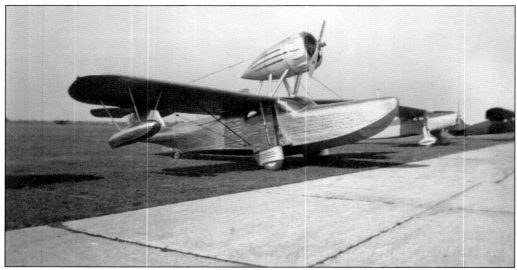

FLEETWINGS F-5 SEABIRD, 1931. Fleetwings' only attempt at production was the F-5, seen here, a five-seat, high-wing, monoplane amphibian that was entirely made of stainless steel that was spot-welded throughout. It was the first stainless steel aircraft to win ATC approval. Unfortunately, during the Depression, airplanes were selling slowly, and expensive amphibians were selling worse; thus only six Seabirds were built before the firm was moved to Pennsylvania in 1934 and soon ceased operation.

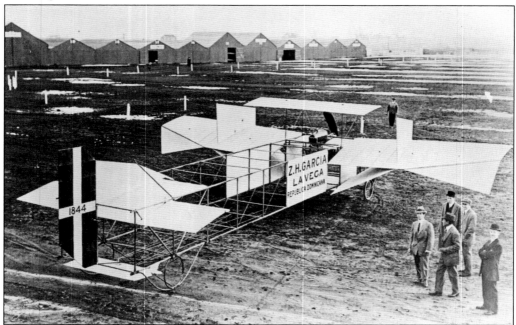

GARCIA POLYPLANE, NASSAU BOULEVARD AIRFIELD, GARDEN CITY, 1911. Another unusual pioneer design, this one was built by Zoilo Garcia, the cigar maker, at Nassau Boulevard Airfield in Garden City. Called a polyplane, meaning "many wings," this was also the first airplane built by a Dominican. Although powered by a 75-horsepower Roberts engine, there is no evidence the aircraft ever flew.

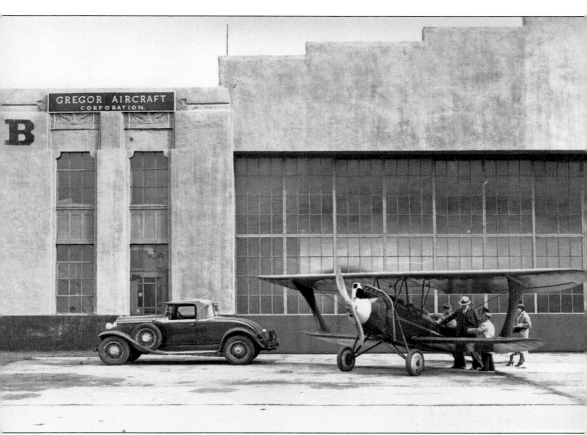

GREGOR GR-2, ROOSEVELT FIELD, C. 1935. Michael Gregor, an aircraft designer of note, emigrated from the Soviet Union in 1921. After first designing the Bird for Brunner Winkle, Gregor established his own firm at Roosevelt Field and produced the GR-1, an efficient two-place sport aircraft powered by a 95-horsepower Cirrus engine. In 1936, he designed the FDB-1, which was produced in Canada. It was one of the last biplane fighters ever built.

THE GRUMMAN FACTORY AND AIRPORT, BETHPAGE, C. 1968. The Grumman Aircraft Engineering Corporation, founded by Leroy Grumman, Jake Swirbul, and William Schwendler, opened for business in Baldwin in 1930. At first, the company built amphibious aircraft floats for the navy, but it soon moved on to building naval aircraft in Valley Stream (1931), Farmingdale (1932), and finally in Bethpage in 1937.

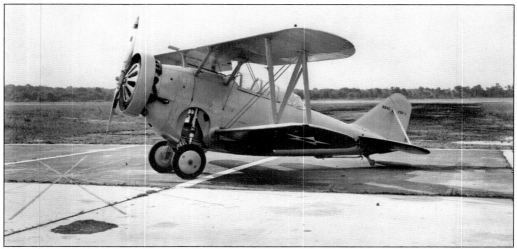

GRUMMAN FF-1, FARMINGDALE, 1932. Grumman won its first contract to build 27 new airplanes in 1931. Designated the FF-1, it was a naval, carrier-based, scout/fighter designed to carry two. It was also the first naval fighter with retractable landing gear. An additional 33 examples, known as the SF-1, were produced for the navy in 1933. All were powered by 750-horsepower Wright R-1820 engines.

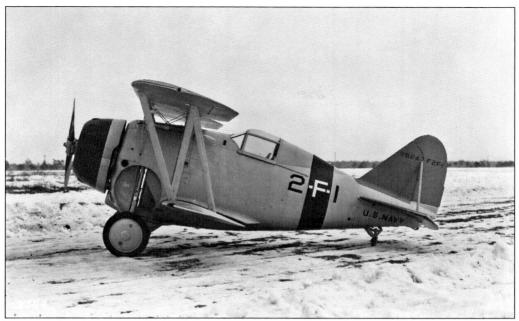

GRUMMAN F2F-1, 1935. The F2F was a single-place follow-on fighter to the FF-1. It was shorter, with a smaller, 650-horsepower Pratt and Whitney R-1535 engine, but it was also lighter and faster. When the navy ordered 55 F2Fs in 1934, it was the largest aircraft order placed since 1918. The navy found the aircraft to have excellent maneuverability and outstanding performance.

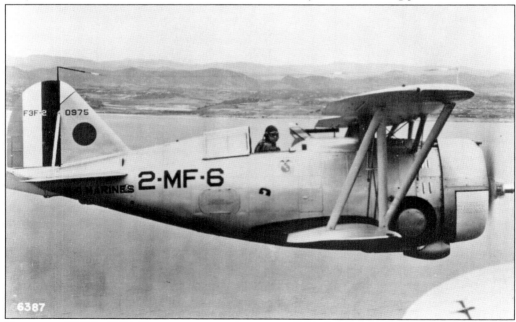

GRUMMAN F3F-2, 1937. First entering production in 1936, the F3F was a larger, more powerful, and faster version of the F2F. The mass-produced F3F (with more than 160 built), was also the navy's last biplane fighter, and it remained in production until 1939. The aircraft was powered by a 950-horsepower Wright R-1820 engine and could reach speeds of more than 250 miles per hour.

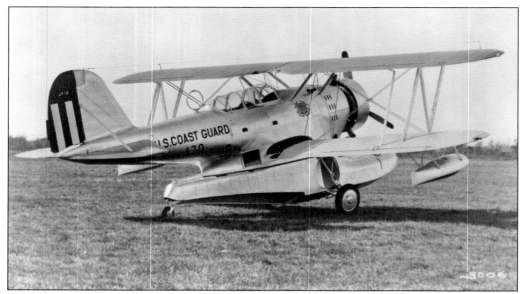

GRUMMAN JF-1 DUCK, c. 1936. During the mid-1930s, Grumman entered the amphibian field with the versatile Duck series (based on an earlier Loening design), which became the navy's most successful amphibious workhorses. A utility amphibian used for transport, reconnaissance, and rescue work, more than 700 were built in several models through 1945. The aircraft was powered by a 750-horsepower Wright R-1820 engine.

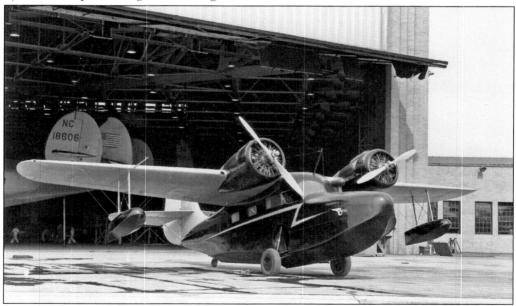

GRUMMAN G-21 GOOSE, LAGUARDIA FIELD, 1940. The Goose was initially produced as a civil amphibian for executive, airline, transport, and survey work. However, the military became the largest customer of the Goose, with more than 250 purchased by the U.S. Navy, U.S. Coast Guard, U.S. Air Corps, and foreign air forces through 1945. The military used them for transport, utility, rescue, and antisubmarine work. They were powered by two 450-horsepower Pratt and Whitney R-985 engines.

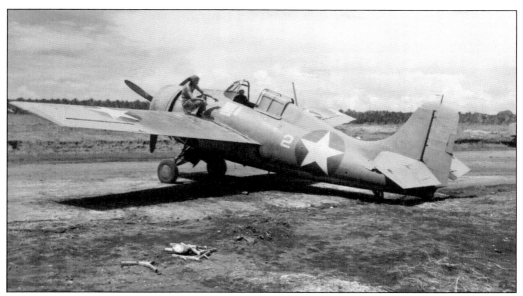

GRUMMAN F4F WILDCAT, GUADALCANAL, 1942. In the late 1930s, Grumman made the transition from fabric-covered biplane fighters to all-metal monoplanes. Early model Wildcats, such as this one, had fixed wings, while later versions featured folding wings so more could be carried aboard aircraft carriers. In production until 1945, almost 8,000 Wildcats were produced. They held the line against superior Japanese fighters in the Pacific until the Grumman Hellcat was placed in service.

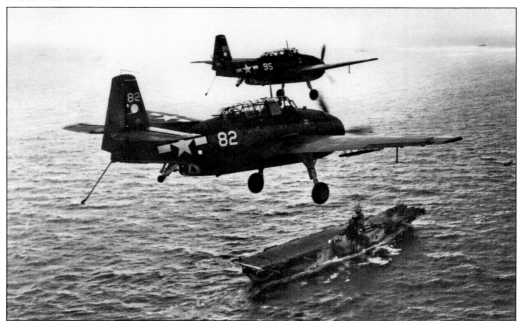

GRUMMAN TBF AVENGER, 1944. The Avenger was a torpedo/bomber and was the largest and heaviest carrier-based aircraft of World War II. Almost 10,000 Avengers were produced, and they were highly successful in destroying Japanese naval and land targets. The Avenger could carry bombs, rockets, or torpedoes, and it was powered by a 1,700-horsepower Wright R-2600 engine.

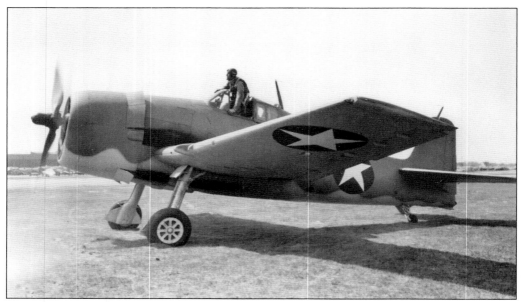

GRUMMAN F6F-3 HELLCAT, 1944. The best naval fighter of World War II, the Hellcat rolled off Grumman's assembly lines in record numbers—more than 600 in one month! Larger, faster, more powerful, and better armed than the Wildcat, Hellcats established a 19–1 kill ratio against Japanese aircraft, and more than 12,000 were produced. They were powered by 2,000-horsepower Pratt and Whitney R-2800 engines. They remained in U.S. naval service until 1953.

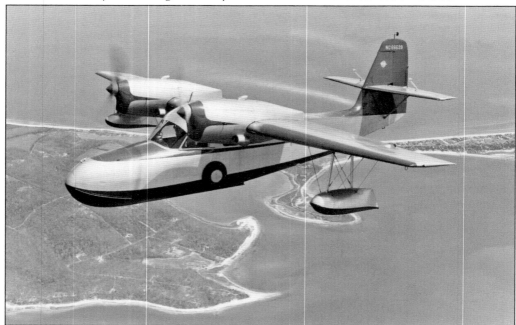

GRUMMAN G-44 WIDGEON, 1945. The Widgeon was a slightly smaller and cheaper amphibian than its counterpart, the Goose. Developed as a civil amphibian, the military soon became the largest customer, using it as a utility transport and antisubmarine aircraft. More than 300 Widgeons were built, and they were powered by two 200-horsepower Ranger 440 engines.

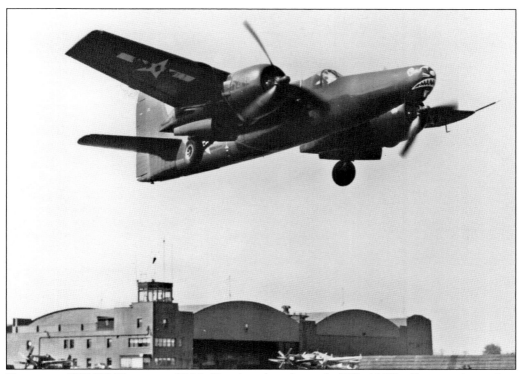

GRUMMAN F7F-3N TIGERCAT, 1946. Developed at the end of World War II as a twin-engine, carrier-based fighter, the Tigercat only saw combat as a night fighter during the Korean War. Developed as a single-place airplane, a second seat was added for the radar operator, and it was widely used for photoreconnaissance work. Many saw long postwar careers as water bombers, and they were powered by two 2,000-horsepower Pratt and Whitney R-2800 engines.

GRUMMAN F8F BEARCAT, 1946. Designed to succeed the Hellcat as a carrier-based fighter, the F8F was light, fast, and highly maneuverable. In spite of these qualities, it was developed too late for World War II and failed to see any action. More than 1,200 Bearcats were produced, and they were powered by 2,100-horsepower Pratt and Whitney R-2800 engines. They remained in U.S. naval service until 1956.

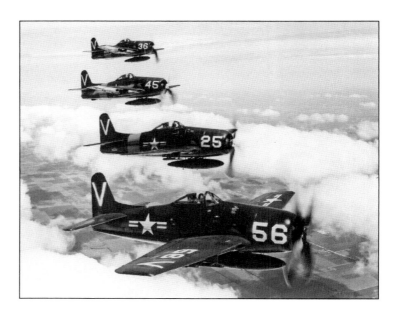

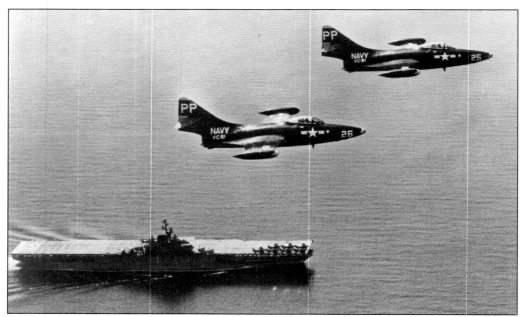

GRUMMAN F9F PANTHER, 1952. Grumman's first jet, the F9F first flew in November 1947. This was also one of the first jets to see combat during the Korean War as a carrier-based fighter/bomber. The Panther was produced in five different models, and it was mostly powered by 7,000-pound thrust Pratt and Whitney J-48 engines. A successful attack aircraft in the Korean War, they remained in naval service until 1958.

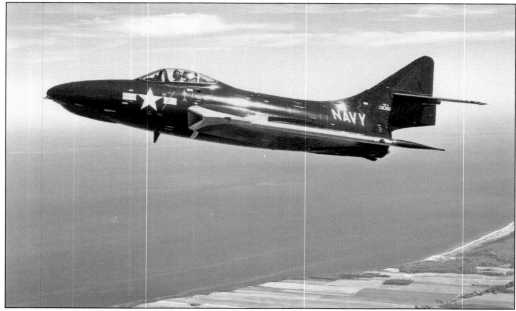

GRUMMAN F9 F-6 COUGAR, 1955. Grumman's first swept-wing jet, the Cougar took to the air in 1951. Essentially a swept-wing version of the Panther (swept back wings for greater speed), it was also produced in trainer and photoreconnaissance versions. The Cougar served with the navy into the early 1970s. It was powered by a 7,250-pound thrust Pratt and Whitney J-48 engine.

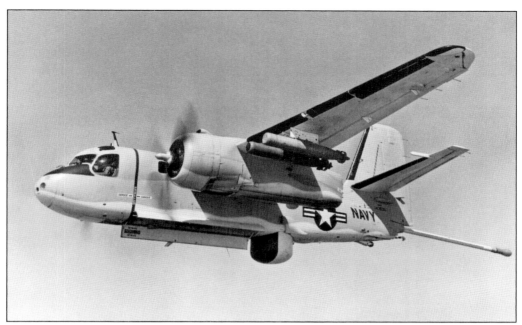

GRUMMAN S2F-3 TRACKER, c. 1960. The Tracker was the navy's first twin-engine carrier-based antisubmarine aircraft. It combined the hunter/killer functions, which previously required two separate aircraft, into one. Later versions of the S2F served as airborne early warning and ship-to-shore transport aircraft. They served in the U.S. Navy into the 1980s and were powered by two 1,525-horsepower Wright R-1820 engines.

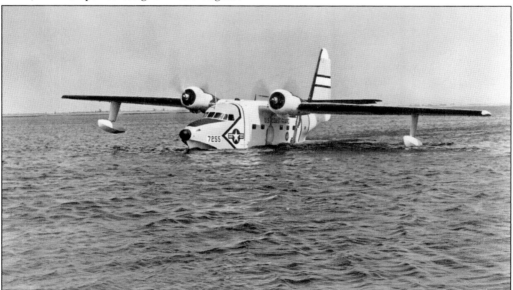

GRUMMAN HU-16 ALBATROSS, c. 1965. First flown in 1947, the Albatross was an air-sea rescue and transport amphibian and was last in a long successful line of Grumman amphibious aircraft. The majority of the 466 built went to the air force as rescue aircraft; the navy and coast guard received the rest for utility amphibians. They served into the mid-1980s and were powered by two 1,425-horsepower Wright R-1820 engines.

GRUMMAN F11F TIGER, C. 1960. Developed in the mid-1950s, the Tiger was Grumman's first supersonic jet. Production continued until 1958, and it remained in naval service as a carrier-based fighter until 1967. However, its short range and small payload limited production to 201 aircraft. It was powered by a 7,400-pound thrust Wright J65 engine. They were armed with four 20-millimeter cannons and four Sidewinder missiles.

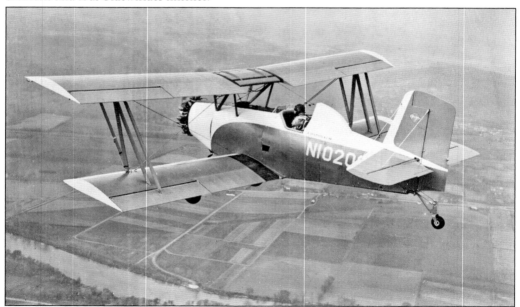

GRUMMAN G-164 AGCAT, C. 1962. Looking for a new, nonmilitary commercial product in 1956, Grumman shocked everyone by developing this crop duster biplane. Although production was later contracted out to Schweizer, the aircraft—known for its simplicity, ruggedness, and durability—remained in production through the 1980s. More than 2,500 Agcats were built, and it is one of the most important agricultural aircraft ever produced.

76

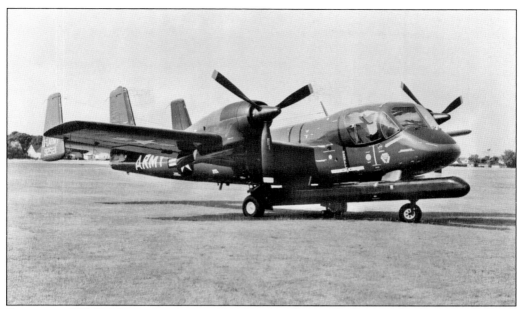

GRUMMAN OV-1D MOHAWK, C. 1970. Grumman's only aircraft designed for the army, the OV-1 was primarily intended for visual reconnaissance and target marking. Later versions carried rockets, bombs, and Side Looking Airborne Radar (SLAR) pods. Normally carrying marking rockets, they were widely used during the Vietnam War. The aircraft was designed to operate on short fields from remote bases and was powered by two 1,150-horsepower Lycoming T-53 turboprops.

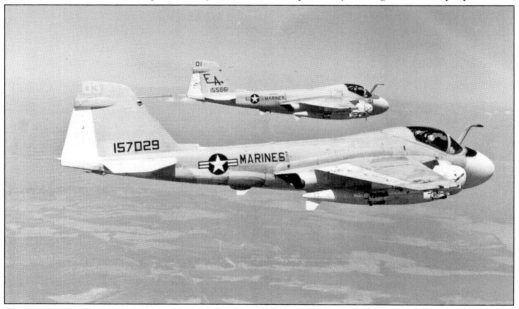

GRUMMAN A-6A INTRUDER, C. 1970. In production between the late 1950s and early 1990s, the A-6 was a carrier-based naval attack aircraft. An all-weather bomber, they saw heavy use in both the Vietnam and Persian Gulf Wars. Produced in several models, the last production version, the EA-6B, was an electronic warfare (jamming) aircraft. Able to carry up to 18,000 pounds of ordnance, they were powered by two 9,300-pound thrust Pratt and Whitney J-52 engines.

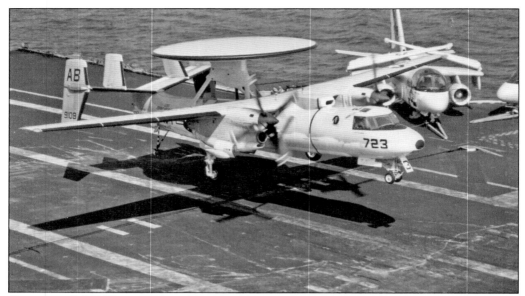

GRUMMAN E-2C HAWKEYE, C. 1980. A turboprop-powered, carrier-based, early warning, and Command and Control aircraft, the Hawkeye remains in production today. With a crew of five, including three radar operators, the Hawkeye carries a large radome on top of the fuselage. First flown in 1960, the current version, the E-2D, features new engines, propellers, electronics, and radar. In 1995, a Hawkeye delivered from Calverton was the last military aircraft ever produced on Long Island.

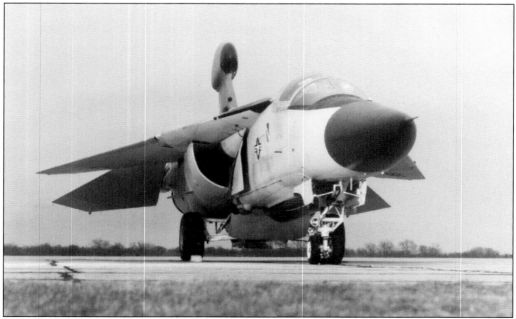

GRUMMAN EF-111 RAVEN, C. 1985. Developed from the F-111 bomber, the Raven was designed to provide electronic detection and jamming of enemy weapons and defenses. Sensors were carried in the belly and tailpod, and it remained in U.S. Air Force service between 1977 and 1999. A total of 42 were built by Grumman through 1985.

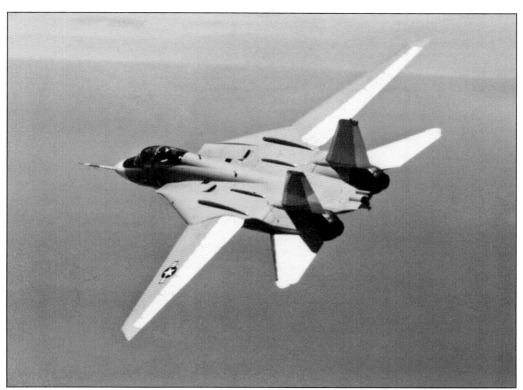

GRUMMAN F-14A TOMCAT, C. 1977. The F-14 was the navy's premier carrier-based fighter between 1970 and 2006. Its unique "swing wing" permitted low-speed carrier landings as well as Mach 2 supersonic flight. Armed with cannons and Sparrow, Phoenix, and Sidewinder missiles, it could engage enemy aircraft up to 100 miles away. Later versions were equipped with new electronics and more powerful GE-F110 engines.

GRUMMAN E-8A, c. 1995. Originally called J-STARS, or Joint STARS, the E-8A is an extensively modified Boeing 707. It now contains an advanced radar system, which provides detailed real-time battlefield surveillance to commanders while remaining clear of the combat area. Used to great effect in both Mideast wars, they remain in production today.

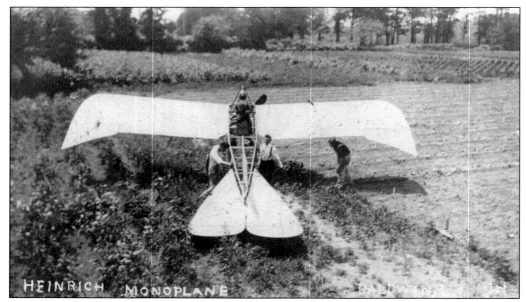

HEINRICH AEROPLANE COMPANY, MODEL A, 1910. Founded by brothers Albert and Arthur Heinrich, this small firm produced several notable aircraft during its short existence. This first aircraft was built in a chicken coop in Baldwin, flown in Mineola, and has the distinction of being the first American monoplane to fly powered by an American engine (Emerson marine). This aircraft was also one of the first to feature true ailerons.

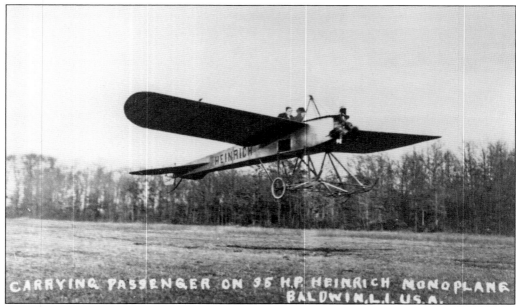

HEINRICH MODEL D, 1911. This, the firm's second successful aircraft, also built in Baldwin, was powered by a 35-horsepower Anzani engine and was able to carry a passenger. This aircraft was fairly streamlined for its day and was designed for school use as a training machine. In fact, the Heinrichs built two and operated a flying school with them at Nassau Boulevard Airfield.

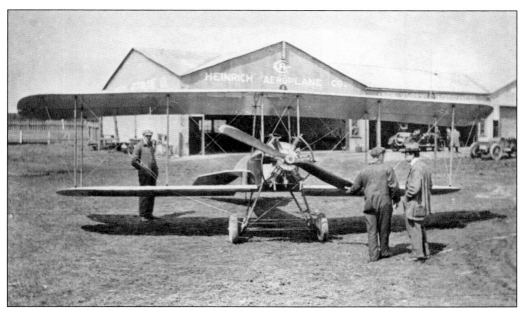

HEINRICH MODEL E, 1914. The Model E, Heinrich's first biplane, was designed for the military as a two-place training airplane, although two passengers could be stuffed into the front cockpit. Also powered by an Anzani engine, only two were built, as no production orders were received from the army. Thus, the Heinrichs used them as training airplanes at their own school on the Hempstead Plains Airfield.

HEINRICH VICTOR, FIGHTER, 1917. A proposed advanced fighter trainer, four were built for the U.S. Army Air Service during World War I. The aircraft was powered by an 80-horsepower LeRhone rotary engine, and it was nicely streamlined for its day. However, the U.S. Air Service favored producing established foreign designs rather than develop its own fighter; thus no further development was undertaken.

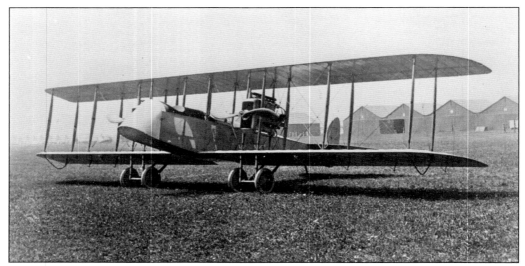

HEINRICH ATLANTIC, BOMBER, 1917. Heinrich built one of these twin-engine bombers for the U.S. Air Service when it was seeking to produce a bomber of American design. The aircraft was first powered by Aeromarine engines (seen here) and later by two Gnome rotaries. Although the aircraft was flown many times at Hazelhurst Field, no further orders were forthcoming, and the firm ceased operation in 1918.

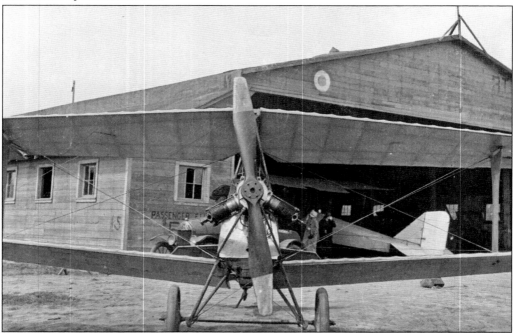

HILD-MARSHONET SPORTPLANE, 1919. Founded by Frederick Hild and Edward Marshonet, formerly owners of the American Aeroplane Supply House, this new firm sought to manufacture sportplanes in Hempstead after World War I. This odd design featured an upper wing that was swept back and a lower wing that was swept forward. First powered by a two-cylinder Harley Davidson engine, later a three-cylinder Lawrance, it also had wings that were removable so the aircraft could be garaged. It appears only two were built in the slow postwar lightplane market.

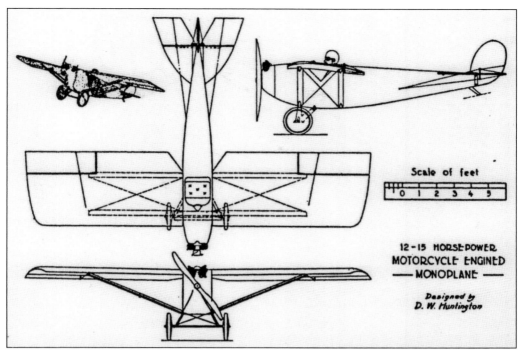

HUNTINGTON H-12 MONOPLANE, 1920. Designed and built by Dwight Huntington of Hempstead, this was the first kit, or plan-built, lightplane professionally engineered in the United States. A small, mid-wing wooden monoplane, it was powered by a 15-horsepower Harley Davidson motorcycle engine. Able to cruise at 60 miles per hour, plans of the H-12 were sold through aviation magazines into the late 1920s. The airplane is credited with starting the wave of enthusiasm for plan-built lightplanes in America. It is unknown how many were built.

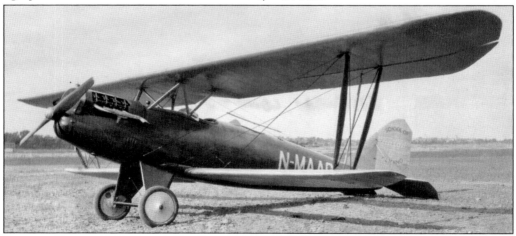

IRELAND COMET, 1925. Founded by Sumner Ireland, an engineer at Curtiss's Garden City plant, Ireland initially produced landplanes using war surplus Curtiss engines. Ireland procured surplus Curtiss Oriole fuselages and designed a new set of single-bay wings for them in his factory at Roosevelt Field. Still OX-5 powered, the aircraft's top speed was improved by about 10 miles per hour. A three-place plane, it appears that at least 12 were produced, nearly all of them being sold overseas.

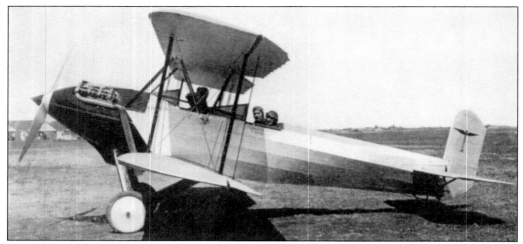

IRELAND METEOR, 1926. Wanting to develop an efficient new airplane with commercial possibilities around the reliable 90-horsepower OX-5 engine, Ireland developed the Meteor. Well-engineered and easy to fly, the Meteor seated four in two roomy cockpits. Only two were sold, so Ireland moved on to designing amphibians.

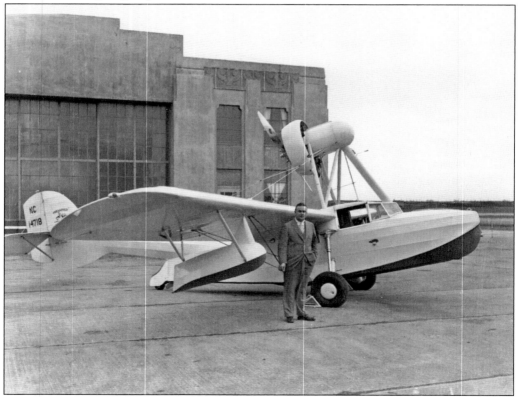

IRELAND NEPTUNE, 1928. In 1927, Ireland began exclusively producing amphibians at the Roosevelt Field factory. He first developed the Neptune, seen here, a five-place amphibian with an aluminum hull powered by a Wright Whirlwind engine. Later versions of the Neptune featured enclosed cockpits, and at least 30 were produced until 1930.

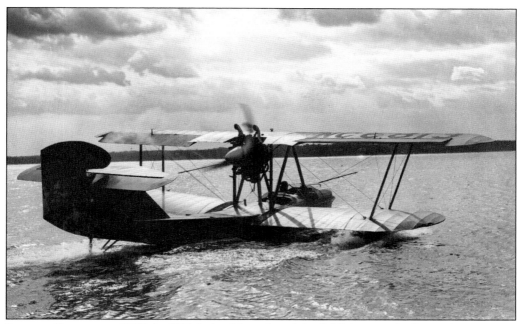

IRELAND PRIVATEER, 1929. In 1929, Ireland introduced the P-2 Privateer, the first serious attempt at a modern personal amphibian. Powered by a Warner Scarab engine, it was able to carry two people, and a total of 12 were produced. However, as with many other aviation firms, due to slow sales during the Depression, Ireland ceased operation in 1930.

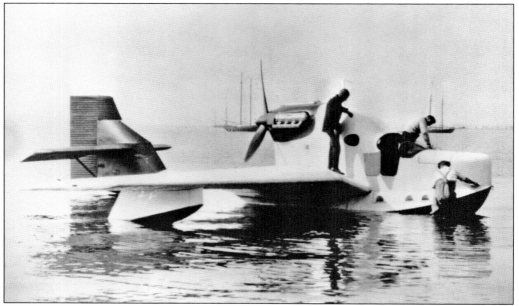

KIRKHAM AEROPLANE AND MOTOR COMPANY, AIR YACHT, 1925. In 1920, pioneer aircraft builder Charles Kirkham began the production of experimental aircraft in Garden City. This streamlined, all-metal flying boat, built for the Vanderbilt family, was able to carry six people in an enclosed cabin. It was powered with a British 450-horsepower Napier Lion engine. (Courtesy Warren Bodie.)

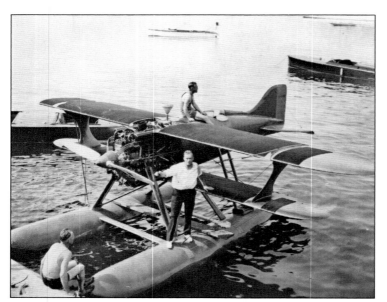

KIRKHAM RACER, 1927. Produced for noted pilot Al Williams (standing on float), this racer was powered by a massive 1,200-horsepower 24-cylinder Packard engine. Unable to compete in the 1927 Schneider Cup races, it later set a world landplane speed record of 322 miles per hour. By 1930, however, Kirkham ceased the production of its own aircraft and became a subcontractor of Grumman through the 1950s.

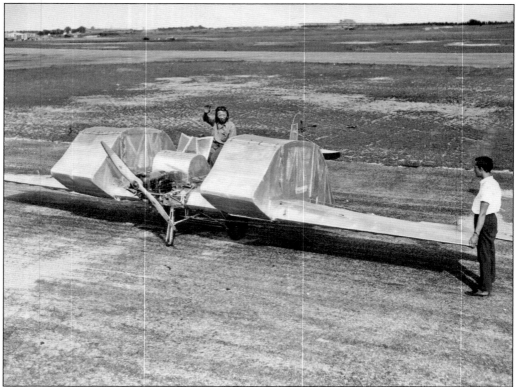

KOUN AIRCRAFT DIRIGIBLE HELICOPTER, ROOSEVELT FIELD, 1939. One of the more unusual aircraft built at Roosevelt Field in Garden City, was this machine, constructed by Young Ho Koun (in cockpit) over the course of five years. It featured a Continental engine that could be tilted straight up and two large boxes on the wings filled with bags of helium. Never able to achieve flight, this was, nonetheless, the first aircraft built by a Chinese American.

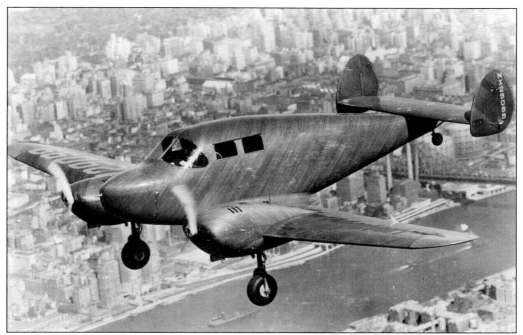

LANGLEY AIRCRAFT CORPORATION, MODEL A, 1940. Founded by Caleb Bragg and Martin Jensen, Langley produced only one aircraft, built in Port Washington. This four-place, twin-engine aircraft was built of a new type of construction, consisting of molded thin sheets of mahogany impregnated with phenolic (fiberglass). Although only one was built, this unique manufacturing process was sold to the Hughes Aircraft Corporation and was later applied successfully in the construction of the massive Hughes H-1 flying boat.

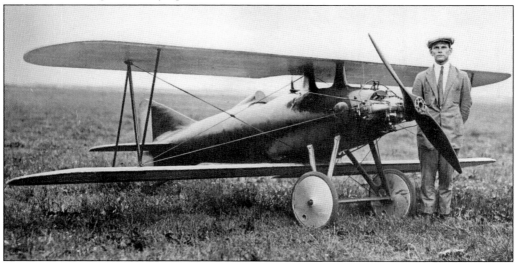

MUMMERT COOTIE, ROOSEVELT FIELD, 1921. Harvey Mummert (pictured here), an engineer with the Curtiss Company in Garden City, began experimenting with midget aircraft in the early 1920s. His first design, the Cootie, seen here, was powered by a two-cylinder 28-horsepower Lawrance engine. The aircraft featured a laminated plywood monocoque fuselage and was based at Roosevelt Field for several years.

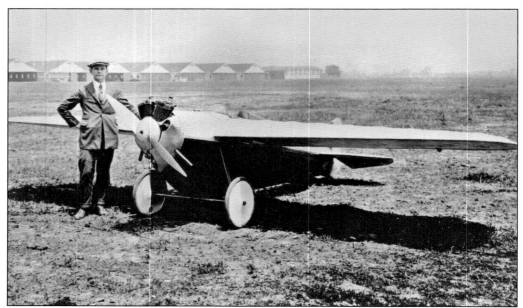

MUMMERT SPORTPLANE, ROOSEVELT FIELD, 1923. Mummert's next experiment in light aircraft design was the Sportplane, powered by an 18-horsepower two-cylinder V-type Harley Davidson engine. The tiny, streamlined monoplane weighed only 285 pounds and also featured a monocoque wooden fuselage and cantilevered wings. By the mid-1920s, Mummert (pictured above) left Curtiss to work for Mercury aircraft in Hasmmondsport, New York, where he continued to design aircraft.

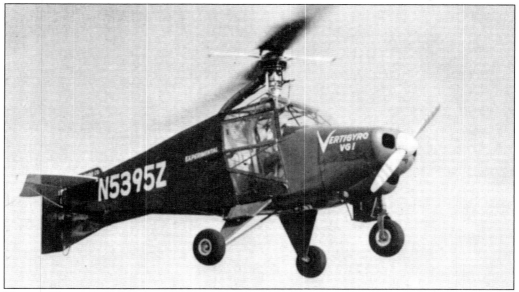

NAGLER HELICOPTER COMPANY VG-1 VERTIGYRO, C. 1960. Bruno Nagler was a helicopter pioneer who began building experimental helicopters in Germany in the 1940s. After settling in Glen Cove in the early 1950s, Nagler built three experimental helicopters, with coaxial rotors, that all appear to have flown. His VG-1, seen here, was powered by both a Lycoming engine (for forward thrust) and a small gas turbine to feed compressed air through the rotor tips. The fuselage was adapted from a Piper Colt. Nagler continued experimenting with helicopters through the 1970s.

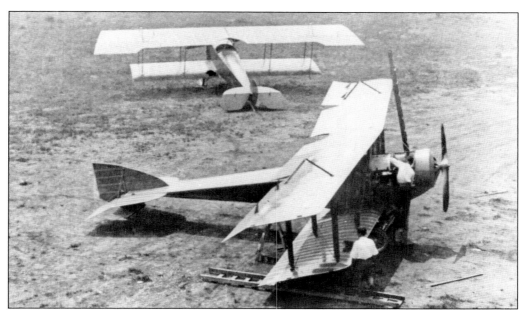

ORDNANCE ENGINEERING COMPANY (ORENCO) MODEL A, 1916. An army training airplane with unusual side-by-side seating, a 105-horsepower Duesenberg engine powered the aircraft pictured here in the rear of the photograph. Two were built and tested by the U.S. Army Air Service; however, the Curtiss Jenny was found to be a superior training airplane so no orders were forthcoming, and only two were built.

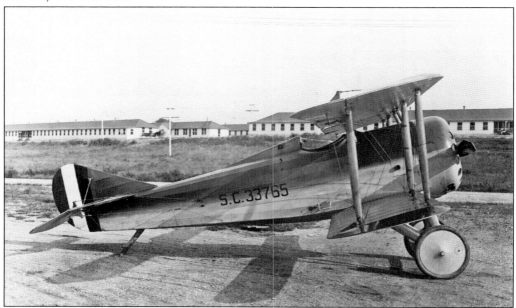

ORENCO MODEL B, HAZELHURST FIELD, 1917. Orenco's first fighter was the Model B, seen here, designed by Walter Phipps along French lines and powered by a 165-horsepower Gnome engine. Two were produced, and the aircraft is noteworthy as being the first fighter to feature wing-mounted machine guns, which anticipated later designs. This was also the first fighter built on Long Island.

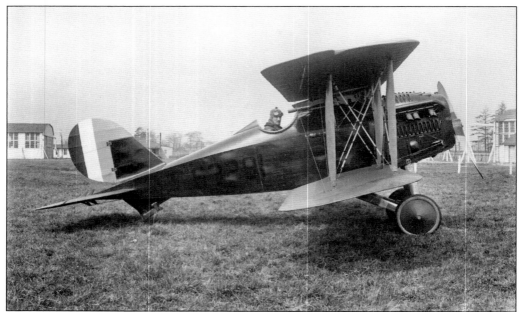

ORENCO MODEL D, HAZELHURST FIELD, 1918. Orenco's more robust Model D fighter was powered by a 300-horsepower Hispano Suiza engine. Although Orenco built four for the U.S. Army Air Service, the firm was underbid by Curtiss for the production contract, who then produced an additional 50 in Garden City. The Orenco Model D was the first American-designed and built fighter to reach operational squadron usage. Test pilot Bert Acosta is pictured above in the cockpit.

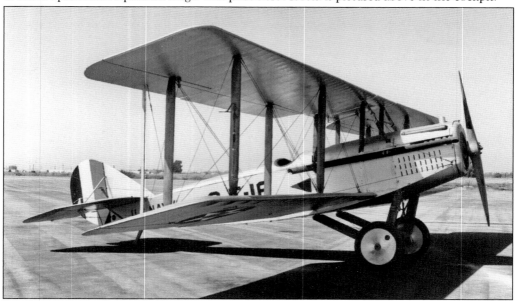

ORENCO MODEL F TOURISTER, 1920. The only Orenco aircraft designed for the civil market, the fairly large Model F was able to seat four in two cockpits. Powered by a Hispano-Suiza engine, it appears that only two were built. One of the survivors was owned by Hollywood pilot Frank Tallman for many years and was used in at least four motion pictures into the 1950s, as seen here in spurious navy markings. (Courtesy Warren Bodie.)

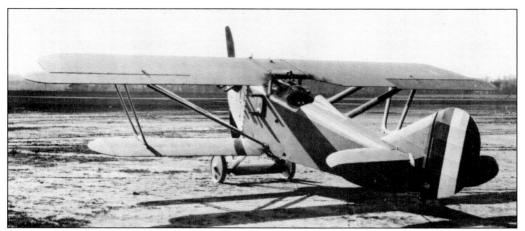

ORENCO PW-3, 1921. An early U.S. Army Air Service fighter design, three PW-3s (Pursuit Watercooled-3) were delivered to McCook Field for testing in 1921. Powered by a 300-horsepower Wright engine, the aircraft featured Pfalz-type laminated wooden interplane struts. However, taxi tests revealed structural weaknesses in the aircraft, and they were declared unfit for flight. After building roughly 25 aircraft, Orenco ceased operation in 1923 due to the lack of military sales.

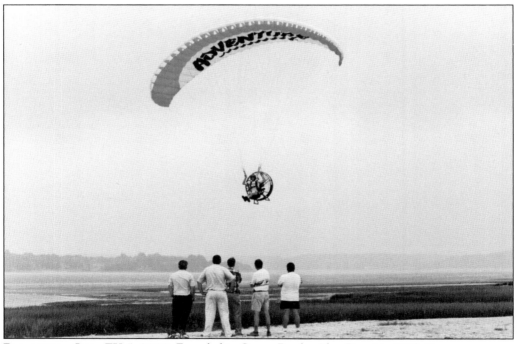

PARAMOTOR, INC., FX-5, 2000. Founded in Oyster Bay by Alan Peseri in 1993, Paramotors are a new type of aircraft. The pilot wears the engine on his back and is supported in flight by a ram-air inflated parachute. The pilot's legs are his landing gear. Paramotors are now in use worldwide by adventurers, the military, and law enforcement agencies. More than 1,000 Paramotors were produced before the firm ceased operation upon the death of its founder in 2006. Other firms continue to produce this model. As of this writing, these were the last aircraft produced in number on Long Island.

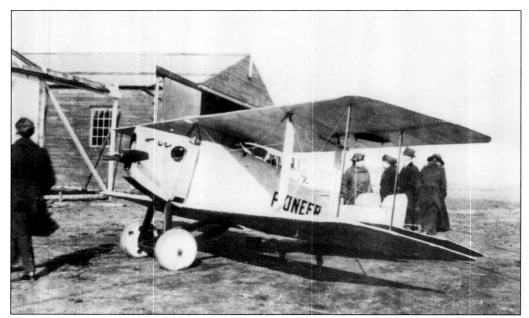

PIONEER AIRCRAFT CORPORATION TYPE A SPORTPLANE, CENTRAL PARK, 1920. Designed by Harry Herzog and built at Central Park Flying Field (Bethpage), the Type A was a single-seat sportplane intended to sell for under $2,000. It was reportedly very stable with a landing speed of 25 miles per hour. It was powered by a 40-horsepower four-cylinder Pioneer engine and had small radiators on both sides of the fuselage. The twin fins and rudders were also unique. However, due to the availability of cheap war-surplus airplanes, there was no market for it, and only one was built.

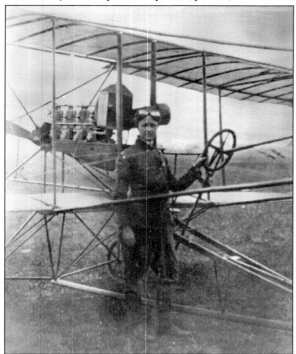

RAICHE BIPLANE, MINEOLA, 1909. Built by Francois and Bessica Raiche in their Mineola home, this aircraft is noteworthy as being the first built by a woman in the United States. The aircraft was powered by a Fox engine taken from a motorboat and was clearly designed along the lines of a Curtiss "pusher." Bessica, seen here, taught herself to fly on this aircraft at the Mineola Flying Field, becoming the first female pilot in America.

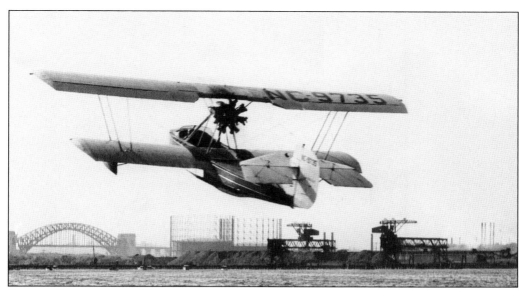

ROGERS AERONAUTICAL MANUFACTURING COMPANY, SEA EAGLE, 1929. Established in 1926 by Harry Rogers, this small firm built two similar aircraft, both at Roosevelt Field in Garden City. Both were open-cockpit biplane flying boats intended for sportsmen pilots. The 1928 Sea Eagle, seen here, was powered by a 225-horsepower Wright J-6 engine, while the 1929 Sea Hawk was powered by a 150-horsepower Curtiss C-6. Both aircraft could carry a pilot and three passengers. Although certified, neither aircraft was placed into production, as there was virtually no market due to the Depression.

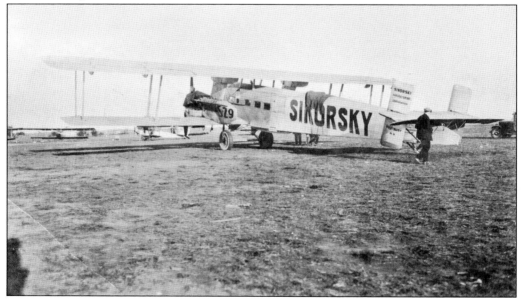

SIKORSKY AVIATION CORPORATION S-29, ROOSEVELT FIELD, 1924. An aircraft designer in Russia, Igor Sikorsky came to America after World War I. By 1923, he raised sufficient backing from other Russian immigrants to build a large twin-engine cabin biplane on a chicken farm in Roosevelt. Thus, the S-29 became Sikorsky's first aircraft built in America, and it had a successful flying career that lasted through the 1920s.

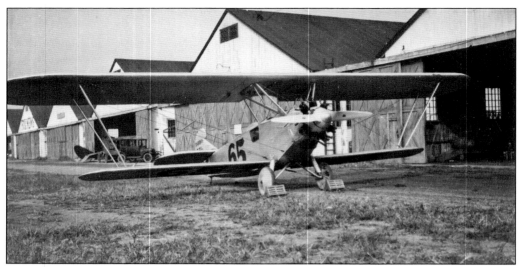

SIKORSKY S-31, ROOSEVELT FIELD, 1925. After setting up a factory in a hangar at Roosevelt Field, Sikorsky's first aircraft produced was the S-31, an all-metal transport for mail, passengers, or aerial photography. It was powered by a 200-horsepower Wright J-4 engine. The only one built was sold to Fairchild Aviation to be used for aerial mapping. Prior to that, it was entered in the 1925 National Air Races, as seen here.

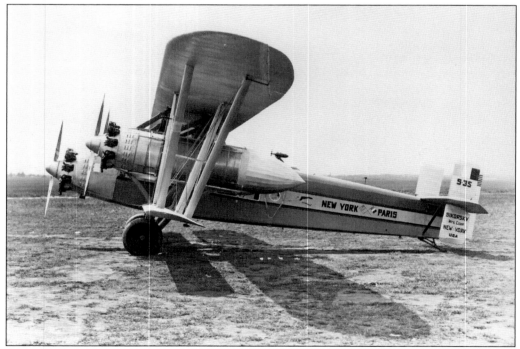

SIKORSKY S-35, ROOSEVELT FIELD, 1926. Designed as a 16-passenger transport, the only S-35 built was used on an ill-fated transatlantic attempt. Attempting to win the Orteig Prize for the first flight between New York and Paris, the S-35, piloted by Rene Fonck, crashed and burned on takeoff from Roosevelt Field, killing two of the crew. It was powered by three 420-horsepower Gnome Rhone Jupiter engines.

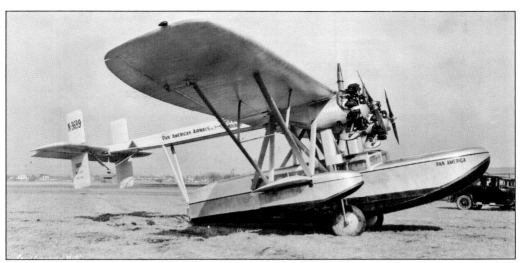

SIKORSKY S-36, ROOSEVELT FIELD, 1927. An eight-seat amphibian, six S-36s were built, with one being sold to infant Pan American Airways. Powered by two 220-horsepower Wright J-5 Whirlwinds, this was the most successful Sikorsky aircraft to date, and it forced the fledgling firm to move into a larger factory in College Point, Queens (the old LWF plant).

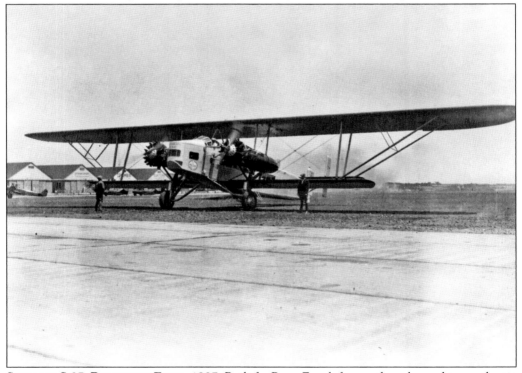

SIKORSKY S-37, ROOSEVELT FIELD, 1927. Built for Rene Fonck for another planned transatlantic attempt, the flight was cancelled when Charles Lindbergh won the Orteig Prize. In 1929, the aircraft was sold to American International Airways as a 20-passenger airliner, and it successfully worked in South America for the next several years. It was powered by two 520-horsepower Gnome Rhone Jupiter engines.

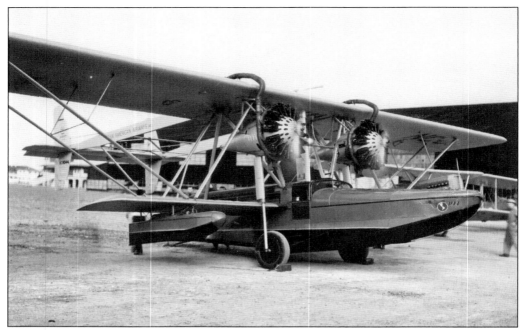

SIKORSKY S-38, 1928. By far Sikorsky's most successful Long Island–built aircraft, the S-38 was a twin-engine, eight-passenger amphibian. It was powered by two 400-horsepower Pratt and Whitney Wasp engines. A total of 111 were built for airline, executive, military, and survey use. Needing more room for expansion, Sikorsky moved to Connecticut in 1929.

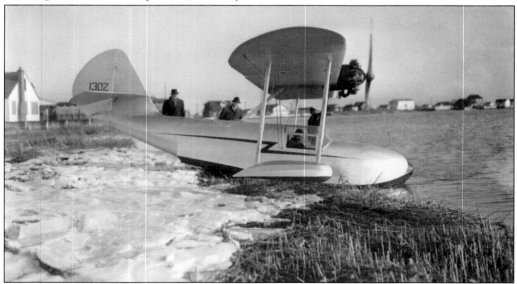

TRIMMER TRIMCRAFT, FREEPORT, 1938. Designed and built by Gilbert Trimmer of Freeport, a mechanic at Roosevelt Field, this small, two-place flying boat with parasol wings was only 20 feet long. Powered by a 50-horsepower, nine-cylinder Salmson engine, the hull was built of plywood. Trimmer had hoped to sell the production rights to an established firm, but he was unsuccessful. In 1944, Trimmer also designed a twin-engine amphibian whose production rights were purchased by Commonwealth Aircraft.

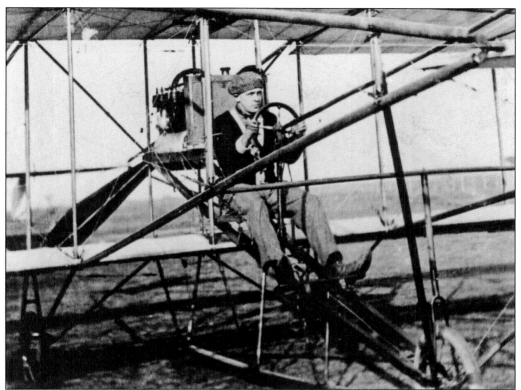

Van Anden Biplane, Mineola, 1909. The first aircraft actually built on Long Island that successfully flew was the machine constructed by Frank Van Anden of Islip (pictured above). Assembled at Mineola Flying Field, it was along the lines of a Curtiss Pusher and was powered by a 50-horsepower Harriman engine. Van Anden flew it at Bayshore in the fall of 1909, where it was damaged in a crash and apparently not repaired. (Courtesy of Gia Koontz.)

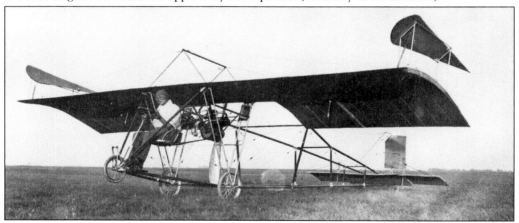

Walden Monoplane Company, Model III, Mineola, 1909. Designed and built by a Mineola dentist, Dr. Henry Walden (pictured here), this was the first successful American monoplane to fly. Powered by a 25-horsepower Anzani engine, it featured vane-like moveable fins over the wingtips that acted, not very well, as ailerons for roll control. Walden had previously built two unsuccessful aircraft in the Bronx.

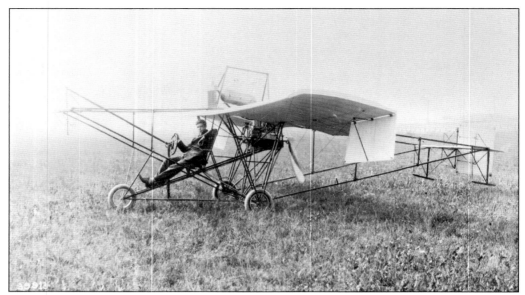

WALDEN IX, MINEOLA, 1910. Walden's most successful aircraft, the Model IX, now featured proper ailerons and was powered by a 40-horsepower Hall-Scott engine. Walden (seated in his aircraft) competed in several air meets with this aircraft and built three more for flying school use, which he operated on Hempstead Plains Airfield through 1914. In all, Walden built approximately 15 aircraft before giving up aviation for dentistry and inventing around 1918.

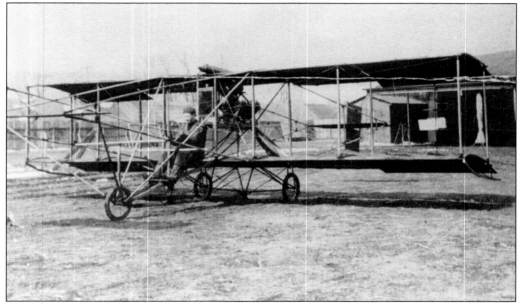

WILLARD-CURTISS EXPRESS, MINEOLA, 1910. When Glenn Curtiss sold his Golden Flyer to the Aeronautic Society of New York, the first person he taught to fly on Long Island was Charles Willard (pictured here). Willard took the aircraft on tour in 1910, sold it, and then built a similar copy in Mineola, as seen here. Equipped with a powerful 63-horsepower V-8 engine on lease from Curtiss, Willard's one real improvement was the addition of proper ailerons to both wings. A second similar model was powered by a Gnome rotary engine. (Courtesy Gia Koontz.)

Four

SUFFOLK COUNTY

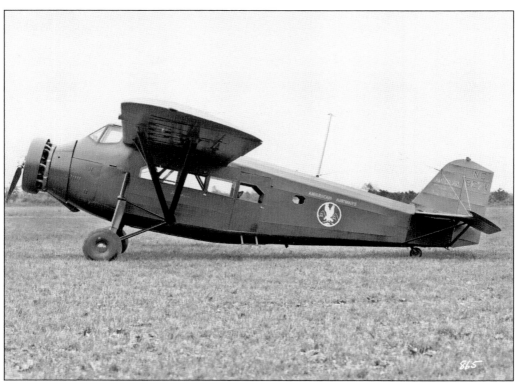

AMERICAN AIRPLANE AND ENGINE CORPORATION (AAE), MODEL 100 PILGRIM, 1930. AAE was formed as a subsidiary of Fairchild in 1930 to build aircraft in a former plant in Farmingdale, with Fairchild having moved to Maryland. The major aircraft the company produced was the Model 100 Pilgrim, a large nine-passenger, single-engine, fabric-covered transport monoplane intended for passenger and cargo use. AAE built a total of 27 Pilgrims, including the first aircraft constructed specifically for American Airways (seen here).

AMERICAN AIRPLANE MODEL 150, FARMINGDALE, 1931. Designed as an all-metal transport, the Model 150 was unusual in that the pilot rode in an open cockpit ahead of the passenger cabin. The design was ultimately sold to the Eastern Aircraft Division of General Motors in 1931, which later produced five as the GA-43. Meanwhile, American Airplane was sold to the Aviation Corporation (AVCO), which discontinued the Farmingdale operations in 1932.

AMES INDUSTRIAL CORPORATION AD-1, 1979. Founded in the early 1970s, the Ames Corporation of Bohemia specialized in the repair and assembly of small jet engines; however, it did build two unusual aircraft. In 1979, the firm built the AD-1, an oblique-wing research aircraft for NASA. Designed by Burt Rutan and built largely of fiberglass, the AD-1 was constructed for the purpose of testing the feasibility of the slew-wing concept. The aircraft was extensively tested by NASA at Moffett Field, where it performed successfully through 1982.

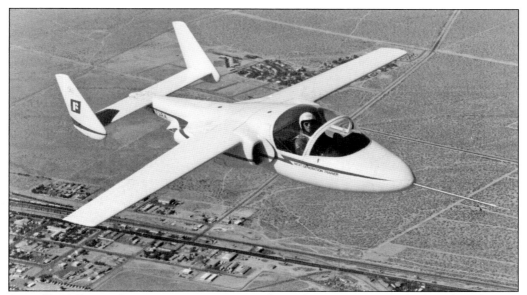

AMES T-46 FLIGHT DEMONSTRATOR, 1981. In the early 1980s, Ames built this 2/3-scale T-46 Flight Demonstrator under subcontract to the Fairchild Republic Corporation. This all-composite, fiberglass aircraft, also designed by Burt Rutan, was flown many times at Mojave as part of Republic's bid to win the USAF T-46 trainer contract, which it ultimately did. However, by 1990, the Ames Corporation was out of the aerospace business. Two Garret Microturbo TRS-18 engines powered both of Ames's aircraft.

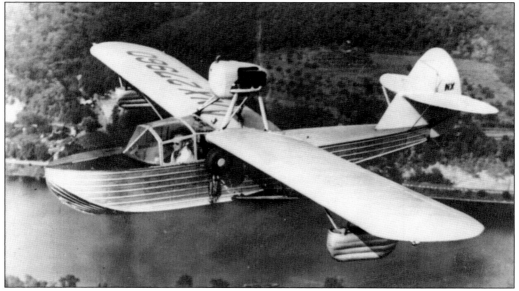

APPLEGATE AIRCRAFT CORPORATION CLIPPER, C. 1940. Ray Applegate founded this firm in Bayshore in 1938 for the manufacture of a new type of amphibian. The two-place, single-engine amphibian had an aluminum fuselage, retractable landing gear, and was powered by a six-cylinder Franklin engine. Applegate tried unsuccessfully to sell the design to Piper in 1940 and to the U.S. Navy in 1941. Unable to build or sell civil aircraft during World War II, the firm ceased operation after only two were built.

BREESE AIRCRAFT CORPORATION PENGUIN, 1918. This firm was founded by James Breese, who had earlier built automobiles. Designed as a non-flying basic trainer, Breese produced 300 Penguins in Farmingdale in 1917 and 1918. These airplanes were designed along the lines of a French Bleriot but with short wings and a 28-horsepower two-cylinder Lawrance engine that did not allow them to fly. Difficult to control on the ground, they were intended to give army student pilots the feel of controlling an airplane at near-flying speeds. This was the only type of aircraft produced by this short-lived firm.

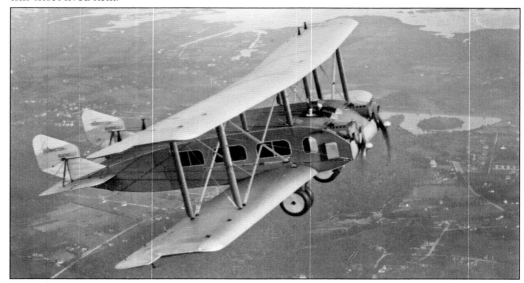

BURNELLI AIRCRAFT CORPORATION RB-1, 1921. Vincent Burnelli was an early advocate of the lifting-body type of aircraft in which the aircraft's airfoil-shaped fuselage also developed lift. This large twin-engine biplane was built in Amityville in 1921 and was successfully flown out of Roosevelt Field for several years. It was the world's first successful lifting-body aircraft and was powered by two 420-horsepower Liberty 12 engines.

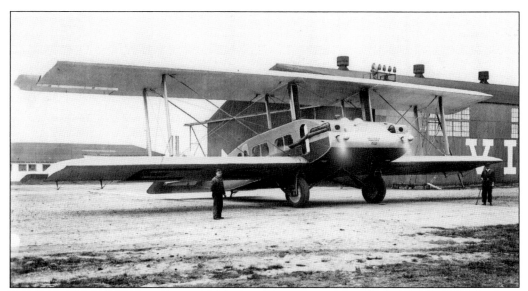

Burnelli RB-2, Mitchel Field, 1924. An improvement over the RB-1, the RB-2, built in Maspeth, Queens, was powered by two 650-horsepower Galloway engines and featured more effective ailerons. Its roomy fuselage could accommodate 25 passengers or 4 tons of freight. At the time, this was the largest freighter in the world, but only one was built. After setting up shop in New Jersey in the late 1920s, Burnelli continued to design lifting-body type aircraft through the 1950s.

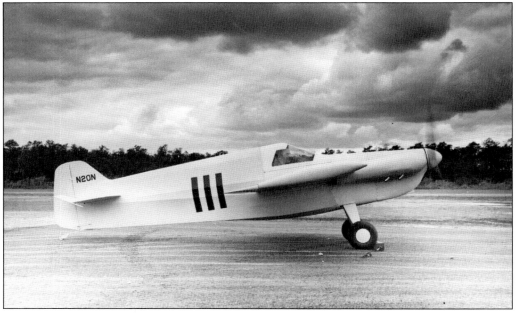

Cassutt Special, c. 1955. Designed and built by Tom Cassutt of Huntington, the Special was based on Steve Wittman's Buster design as a racing plane, and one won the 1958 National Air Racing Championship. A single-place simple Formula One racer, plans of the Special were made available to amateur constructors, and as a result, many Cassutt Specials have been built and raced.

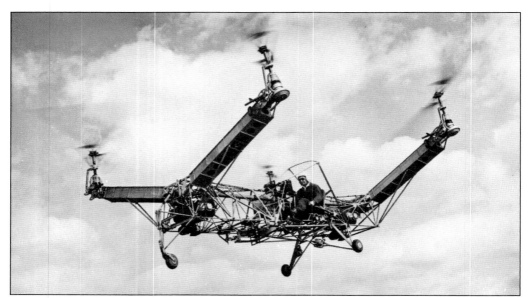

CONVERTAWINGS, INC., MODEL A QUADROTOR, C. 1956. Convertawings was organized by David Kaplan in 1950 at Zahn's Airport in Amityville to develop an entirely new type of helicopter. The Model A, seen here, featured two engines driving four rotors, and small wings could be attached for additional lift in forward flight. Successful in operation, the Quadrotor was a precursor to modern, vertical rising aircraft that feature wings. Without military support for additional development, Convertawings ceased operation in 1957.

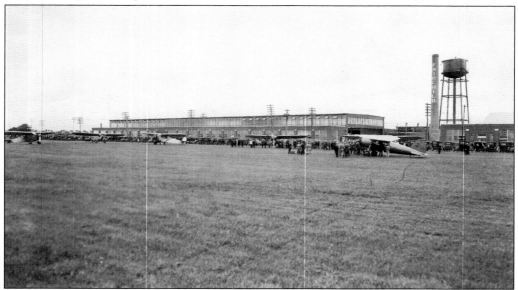

FAIRCHILD AVIATION CORPORATION FACTORY, FARMINGDALE, C. 1929. Founded by the inventor Sherman Fairchild in 1925, this firm began by producing new types of aerial cameras. As there was no suitable stable aerial platform available for his cameras, Fairchild soon began producing aircraft specifically designed for aerial photography. They featured roomy enclosed cabins and were built for stability, not speed. By 1926, Fairchild had erected its own aircraft factory and flying field in Farmingdale.

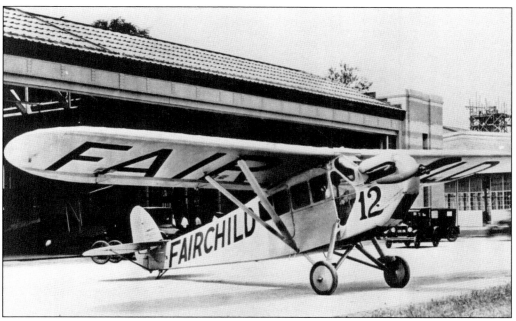

FAIRCHILD FC-1, 1927. Fairchild's first aircraft, the FC-1, was a high-wing monoplane with a heated, enclosed cockpit and cabin in order to protect the crew and their equipment. The airplane provided a steady camera platform and featured unique folding wings. A Curtiss OX-5 engine powered the prototype, but production models incorporated the more powerful Wright Whirlwind.

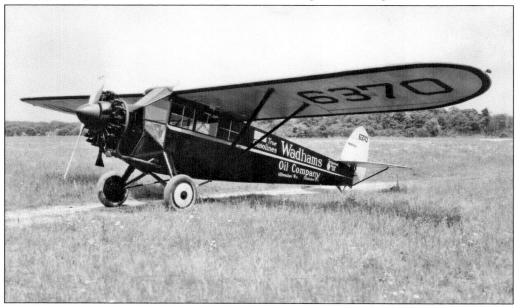

FAIRCHILD FC-2, 1928. Fairchild's first aircraft to reach large-scale production was the FC-2, which was bigger than the FC-1. It could carry five passengers or freight in its large enclosed cabin. It was also available with floats or skis. This was one of the first aircraft purchased by Pan American Airways. Powered by a 220-horsepower Wright J-5 engine, they were the first successful cabin monoplanes built in America, and more than 150 were produced through 1930.

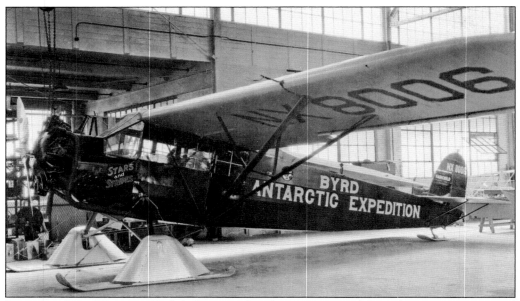

FAIRCHILD FC-2W, 1929. Slightly larger and with a more powerful 400-horsepower Pratt and Whitney Wasp engine, 50 FC-2Ws were produced. Used by airlines, the military, corporations, and for airmail, the most famous usage of this type was on the Byrd Antarctic Expeditions. Fairchild's *Stars and Stripes*, seen here, was flown over the Antarctic for mapping purposes on both the 1929 and 1934 expeditions.

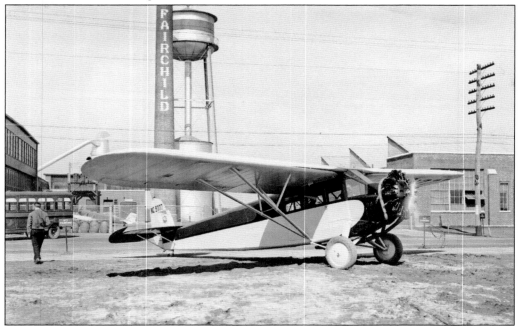

FAIRCHILD MODEL 71, 1929. An improved model FC-2, more than 100 Model 71s were produced through 1931. The 71 was a large, seven-place monoplane widely used by airlines, air freight companies, the military, bush pilots, and for aerial mapping. By 1930, Fairchild had become the largest producer of cabin monoplanes in the world.

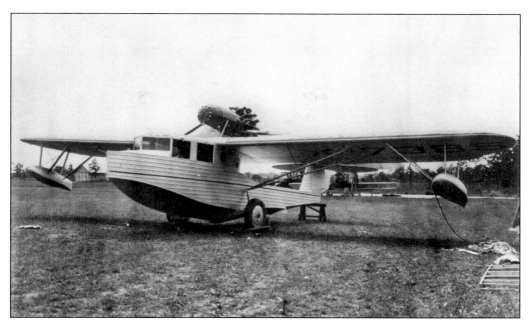

FAIRCHILD FB-3 AMPHIBIAN, 1929. A novel all-metal amphibian powered by a 410-horsepower Pratt and Whitney Wasp engine, this aircraft had the misfortune to appear just as the Depression struck. It featured a richly appointed interior, including leather seats and wood paneling. Designed as a flying yacht for the luxury market, only one was produced.

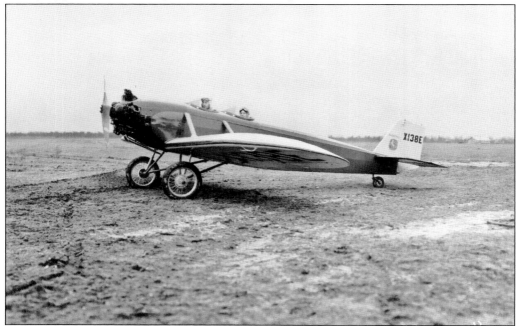

FAIRCHILD MODEL 21, 1929. Designed as a simple, economical, two-seat, low-wing monoplane trainer, the Model 21 was powered by an 80-horsepower Armstrong Siddeley Genet engine. Yet again, the start of the Depression in 1929 caused the market for the 21, and most other civil aircraft, to disappear altogether, and only two were built.

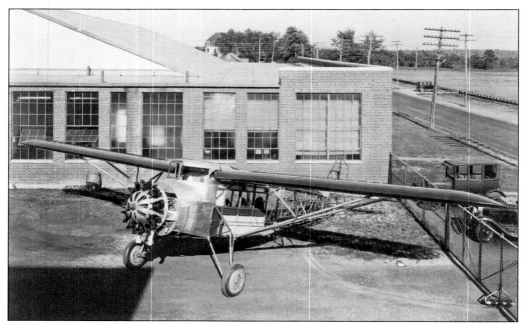

FAIRCHILD MODEL 100 (PROTOTYPE), 1930. Powered by a 575-horsepower Pratt and Whitney Hornet, this design was a large single-engine transport. Only one was built, but it served as the prototype for the later successful American Airplane and Engine Pilgrim. In 1930, Fairchild was sold to the conglomerate Aviation Corporation (AVCO), and it was moved to Hagerstown, Maryland.

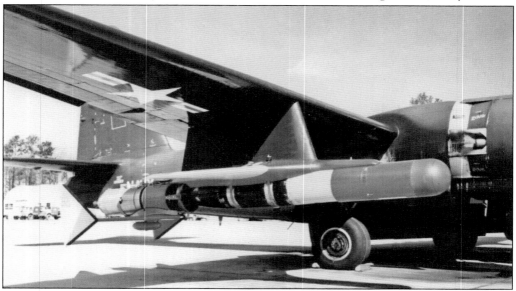

FAIRCHILD GUIDED MISSILES DIVISION AUM-N-2 PETREL, c. 1956. The Fairchild Guided Missiles Division was established by the Fairchild Corporation in Wyandanch in the late 1940s for the development of new types of military missiles. The most successful product was the Petrel, a standoff antishipping and antisubmarine missile usually carried by a Lockheed P2V Neptune. Deployed in the late 1950s, they were powered by Fairchild J-44 Turbojet engines and were fitted with Mk21 homing torpedoes.

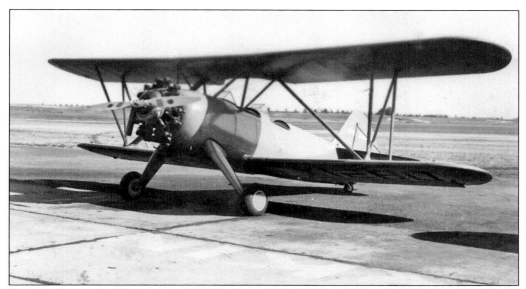

FEDERAL AIRCRAFT CORPORATION, XPT-1, 1936. Federal Aircraft of Lindenhurst was formed with the intention of competing in the army competition for a new basic trainer. The XPT-1, designed by Alan Morse, was strong, stable, and easy to fly. The aircraft was test flown at Roosevelt Field and then delivered to the U.S. Air Corps. Acceptance testing found the aircraft to be robust and easy to fly; however, the simpler Stearman would be faster and cheaper to produce, and so only one XPT-1 was built.

GYRODYNE COMPANY OF AMERICA (GCA) FACTORY AND FLYING FIELD, SAINT JAMES, C. 1968. Gyrodyne was founded by Peter Papadakos in 1948 in order to produce a totally new type of helicopter. GCA planned on producing coaxial helicopters, which is helicopters with two sets of counter-rotating blades, thus producing no torque, so no tail rotor was needed.

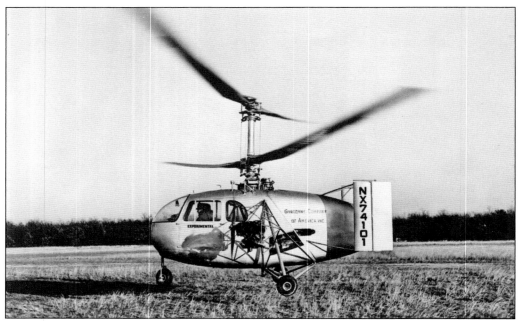

GYRODYNE MODEL 2B, HELIDYNE, SAINT JAMES, 1950. Gyrodyne's first helicopter, the 2B, was a novel design combining coaxial helicopter blades with two additional conventional Continental engines fixed to the sides for forward propulsion. This was an experimental prototype Convertiplane powered by three engines. It was developed to work out the coaxial concept.

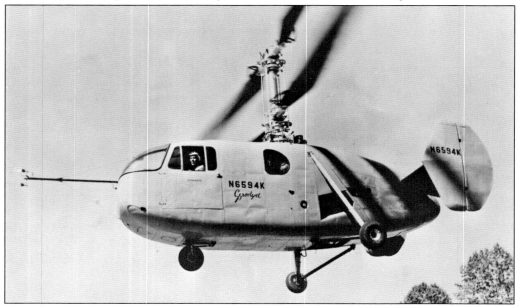

GYRODYNE MODEL 2C, SAINT JAMES, 1952. Another flying test-bed for the coaxial design, the successful 2C made many flights through the 1950s. A six-place design, this is still the largest helicopter ever built on Long Island. It was powered by a 450-horsepower Pratt and Whitney Wasp engine. As there never appears to have been any attempt to produce this model, only one was built.

GYRODYNE XRON ROTORCYCLE, 1956. Designed as a one-man reconnaissance helicopter for the marines, a total of 18 were produced under a development contract. Using the same coaxial rotor design, the helicopter weighed 500 pounds and was extremely maneuverable, easy to fly, and powered by a 72-horsepower Porsche engine. At the time, this was the only coaxial helicopter in production in the world.

GYRODYNE QH-50C, 1962. By far Gyrodyne's most successful product was the QH-50, an unmanned antisubmarine helicopter. The DASH (Drone Anti-Submarine Helicopter) was first produced in 1958 and continued in fleet service until 1972. QH-50s carrying torpedoes, as seen here, were remotely controlled from U.S. Navy destroyers and were intended to keep the ship at a safe distance while attacking enemy submarines. It was powered by a 365-horsepower Boeing T50 turbine engine. A total of 750 QH-50s were produced; however, due to operational and financial difficulties, Gyrodyne ceased helicopter production in 1973.

McRae Super Dart, Deer Park Airport, 1953. Built in Brentwood, the Super Dart, designed by Jack McRae, was an updated version of the 1924 Driggs Dart. Powered by a 55-horsepower Lycoming engine and with more refined aerodynamics than the 1924 Dart, McRae greatly simplified construction and improved performance. It was flown to the first five EAA "Fly-Ins," and it clearly had some impact at the beginning of the homebuilding movement.

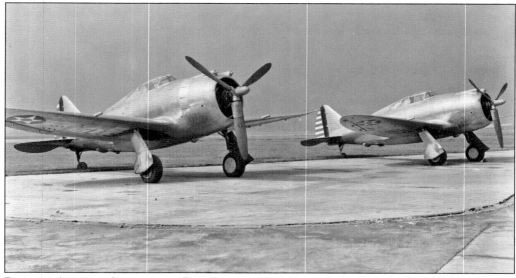

Republic Aviation Corporation P-43 Lancer, 1940. Formerly the Seversky Aircraft Corporation, the firm was reorganized and renamed Republic in 1939, and the new management team immediately began to improve the existing fighter design into a powerful new aircraft. Developed from the Seversky AP-9, the P-43 was the firm's most successful aircraft to date, with more than 200 produced for the U.S. Air Corps through 1941. The P-43 was an interim design that served as an important stepping stone for greater things to come. It was powered by a 1,200-horsepower Pratt and Whitney R-1830 engine.

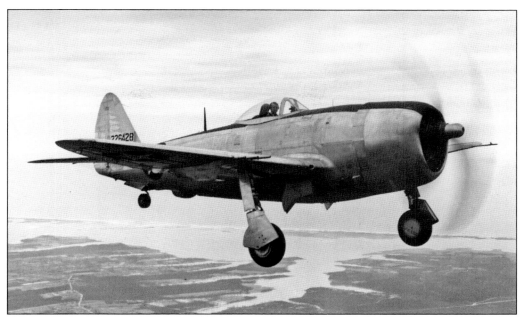

REPUBLIC P-47D THUNDERBOLT, 1944. First ordered by the army in 1940, the P-47 was possibly the greatest fighter of World War II. Designed by Alexander Kartveli, it is the most produced American fighter in history, with more than 15,000 built. A heavily armed, and armored, fighter/bomber, it was also a successful Close Air Support aircraft. P-47s established a 5-1 kill ratio against enemy aircraft in Europe, destroying almost 7,000 of them. It was powered by a 2,000-horsepower Pratt and Whitney R-2800 engine.

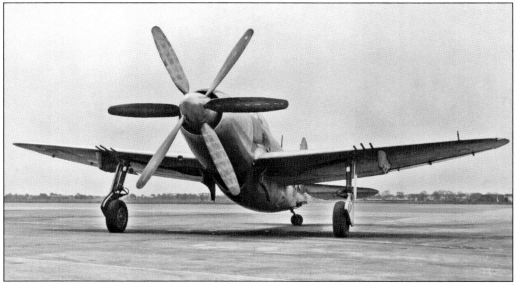

REPUBLIC XP-72, 1945. Intended to be the fastest and highest flying of the Thunderbolt family (up to 490 miles per hour), the XP-72 incorporated a massive 3,500-horsepower Pratt and Whitney R-4360 engine. Two were built in 1944. One, as seen here, was equipped with counter-rotating propellers. Unfortunately, the airplane appeared too late for World War II, so no further production resulted.

REPUBLIC JB-2 BUZZ BOMB, 1945. A direct American copy of the German V-1, more than 75 JB-2s were produced by Republic in 1945. It was intended to be launched from ships for the invasion of Japan, but the end of World War II precluded this. Powered by a Ford Pulsejet engine, most were later expended in an early American guided missile program.

REPUBLIC RC-3 SEABEE, 1947. Attempting to get in on the anticipated postwar civil aircraft boom, Republic developed this roomy, simple, robust amphibian (from the Spencer Air Car) in 1945. Equipped with a 200-horsepower Franklin engine, 1,050 were produced into 1947. In spite of the aircraft's many fine qualities, sales were not as anticipated, and the program was suspended.

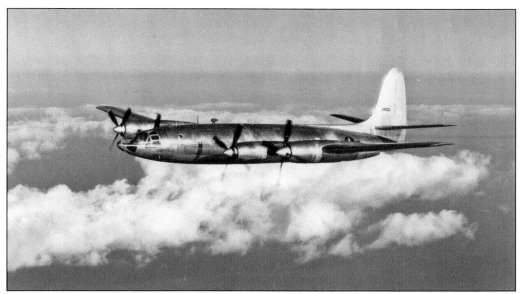

REPUBLIC XF-12 RAINBOW, 1947. The Rainbow was developed in 1944 as a high-altitude, long-range photoreconnaissance aircraft. Its highly streamlined design featured four 2,000-horsepower Pratt and Whitney R-2800 engines, allowing it to cruise at 450 miles per hour, and it had a pressurized cabin. Only two were built, as the U.S. Air Force no longer needed such an aircraft with the war's end, and attempts to sell it as a swift new airliner were unsuccessful due to the glut of cheap surplus military transports available.

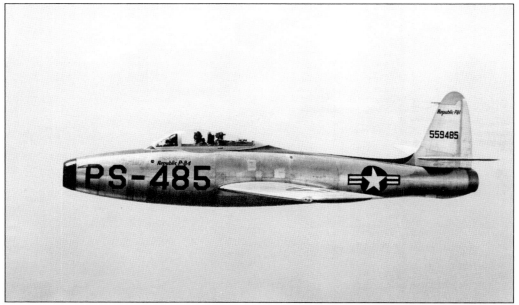

REPUBLIC P-84B THUNDERJET, 1947. Republic's first jet, the P-84, first flew in 1946. Powered by a 5,000-pound thrust Allison J-35 engine, more than 200 were produced through 1948. They were the first new American postwar fighters. Later "straightwing" Thunderjet models saw widespread use in the Korean War as fighter/bombers. More than 3,000 F-84 Gs were produced and armed with machine guns, rockets, and bombs.

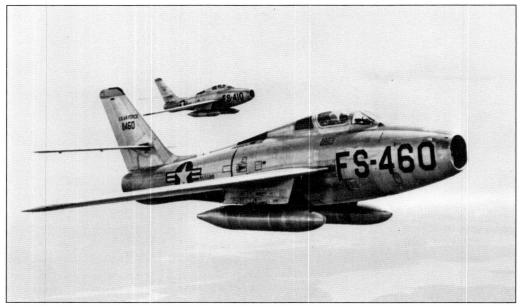

REPUBLIC **F-84F** THUNDERSTREAK, **1954.** Originally planned as a swept-wing version of the Thunderjet, the F-84F turned out to be an all new aircraft. It featured swept wings for greater speed (with a top speed of 690 miles per hour), in-flight refueling, and increased bomb and rocket payload. More than 2,700 were produced for the U.S. Air Force and several NATO countries. They were powered by 7,800-pound thrust J65 engines.

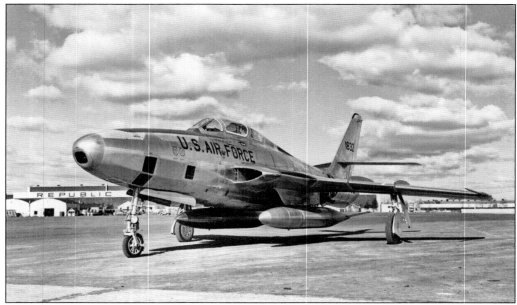

REPUBLIC **RF-84F** THUNDERFLASH, **1957.** A further development of the F-84F, the Thunderflash featured several cameras in the nose for photoreconnaissance use. The concept was to develop a reconnaissance aircraft that could perform as a fighter if engaged. More than 700 were produced for the U.S. Air Force, NATO, and Taiwan, and it was also powered by a Curtiss Wright J65 engine.

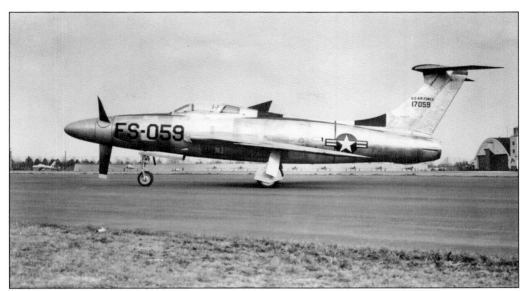

REPUBLIC XF-84H, 1955. One of Republic's oddest designs, the XF-84H was essentially a jet engine driving a supersonic propeller. It was an attempt to get the high speed of a jet combined with the quick acceleration of a propeller-driven aircraft. However, testing revealed many problems, and only two were built. Developed for the navy, it was powered by an Allison XT-40 engine.

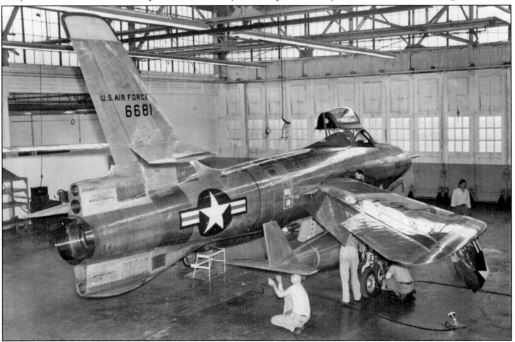

REPUBLIC XF-91 THUNDERCEPTOR, 1950. The XF-91 was a mixed-propulsion fighter using a jet engine for most flight and a cluster of four small rocket engines in the tail for added thrust during climb and interception. Developed as the only way to achieve supersonic flight in a fighter, the design was obsolete by the time it was completed; thus only two were built. One of these became the first American fighter to exceed Mach 1 in level flight.

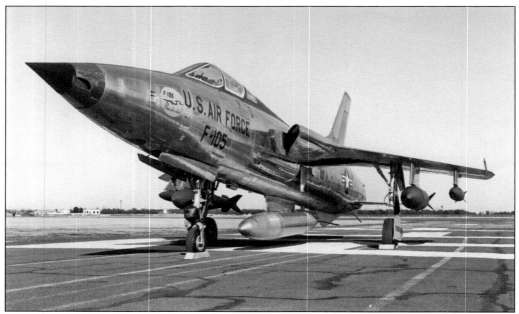

REPUBLIC F-105D THUNDERCHIEF, C. 1965. Designed as a long-range, high-speed nuclear bomber, the F-105 first flew in 1956. Capable of Mach 2 speeds, the all-weather F-105D was pressed into service in Vietnam as a tactical bomber. F-105s conducted most of the U.S. Air Force bombing of North Vietnam between 1965 and 1972. It was powered by a 26,000-pound thrust Pratt and Whitney J-75 engine.

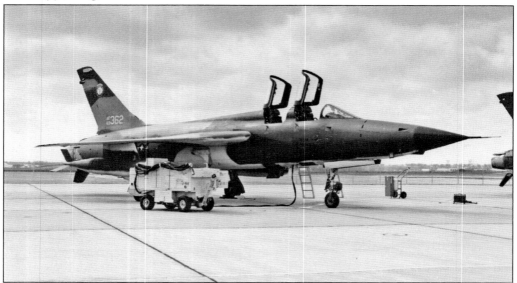

REPUBLIC F-105F THUNDERCHIEF, C. 1970. Originally designed as a two-place training airplane, the F-105F was modified as a Close Air Support aircraft in order to suppress enemy anti-aircraft missile fire over Vietnam. The F-105F and F-105G were successful in this "wild weasel" air defense suppression mission using missiles designed to lock on to enemy radar installations. A total of 833 F-105s were built in all models before production ended in 1964. Due to financial difficulties, in 1965, Republic became an operating division of the Fairchild Corporation of Hagerstown, Maryland.

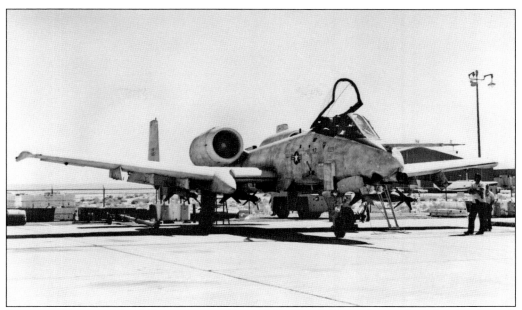

FAIRCHILD-REPUBLIC A-10 THUNDERBOLT II, C. 1980. The A-10 was designed as a low-level attack aircraft in order to counter the threat of Soviet tanks in Europe. Widely used in two Mideast wars, it has proven to be the best Close Air Support aircraft in history. Heavily armed and armored, with twin engines (two 9,000-pound thrust GE TF-34) and redundant systems, the A-10 can carry up to 16,000 pounds of mixed ordnance. A total of 713 were built between 1972 and 1984.

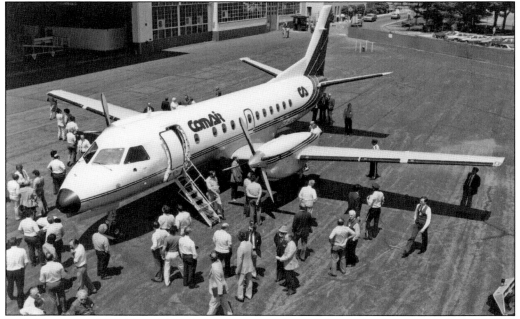

SAAB-FAIRCHILD SF-340, C. 1984. In an attempt to diversify beyond military aircraft, the SF-340 was developed, a 34-passenger turboprop regional airliner jointly designed and produced by Fairchild Republic in Farmingdale and Saab in Sweden. Republic produced the wingsets, nacelles, and tail surfaces, and the firm produced a total of 108 before ceasing production in 1987.

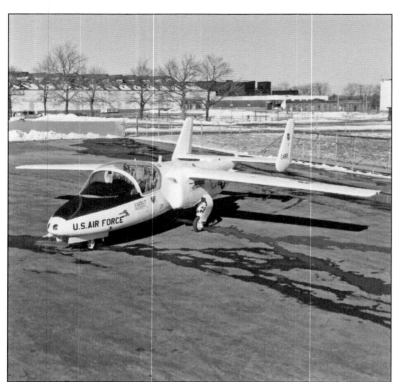

FAIRCHILD REPUBLIC T-46A, 1986. Designed as a new trainer for the U.S. Air Force, the T-46 proved simple and easy to fly. It featured side-by-side seating, a pressurized cockpit, and was powered by two 1,330-pound thrust Garrett F109 engines. However, only three were produced before the air force cancelled the contract in 1987, forcing Republic to cease all operation and liquidate.

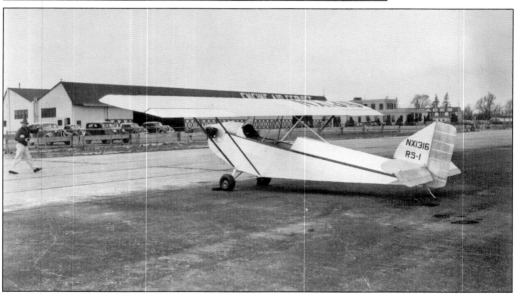

ROSS AIRCRAFT CORPORATION RS-1 PARASOL, ROOSEVELT FIELD, 1940. Designed and built by Orrin Ross in Amityville, the RS-1 was intended to be a low-cost sportplane, selling for under $1,000. Strictly a no-frills airplane, it was powered by a 40-horsepower Continental engine. The RS-1 was a simply designed, two-place, high-wing monoplane. Although the aircraft flew well, it appeared several years too late, as World War II interfered with hoped-for production. Had it appeared earlier, it is possible it might have been built in the thousands, as Orrin Ross predicted.

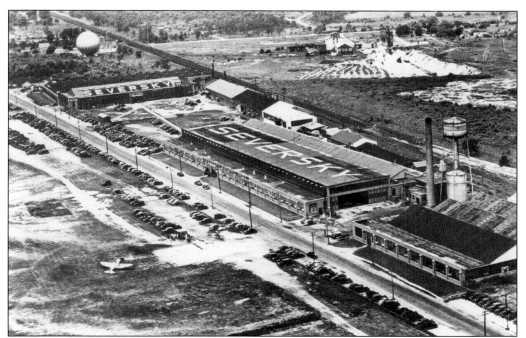

SEVERSKY AIRCRAFT CORPORATION, FARMINGDALE, 1937. Founded by Russian émigré Alexander deSeversky, this firm was primarily a contractor for the U.S. Army Air Corps. Seversky came to America at the end of World War I and immediately began designing aircraft components and then complete aircraft with the intention of military sales. In the early 1930s, he purchased the former Fairchild factory and flying field in Farmingdale, and began producing a long series of successful military aircraft.

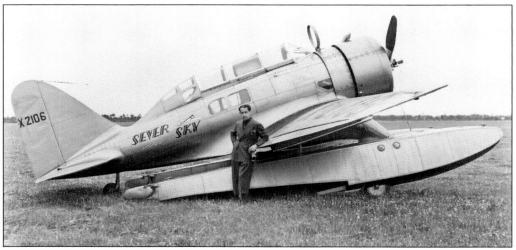

SEVERSKY SEV-3, FARMINGDALE, 1934. Designed by Alexander deSeversky (pictured here), the SEV-3 was an advanced and record-setting amphibian. The aircraft set numerous speed and distance records for amphibians in 1934 and 1935, which attracted the interest of the U.S. Army Air Corps. The aircraft saw the first use of the Seversky elliptical wing (which continued on through the P-47), and it was powered by a 710-horsepower Wright 1820 engine. Later versions were sold to the Colombian Air Force.

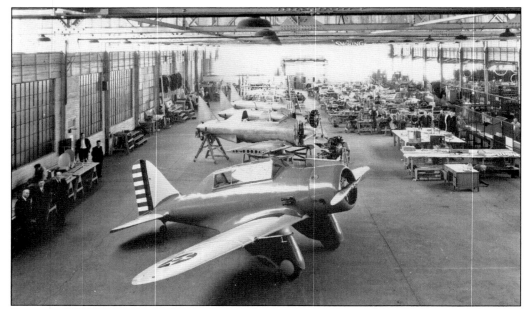

SEVERSKY BT-8 PRODUCTION LINE, 1936. A further development of the SEV-3 design, the BT-8 was a basic trainer built for the U.S. Army Air Corps. An all metal, fixed-gear, two-place training airplane, 35 were produced through 1936. It was the U.S. Army Air Corps's first low-wing trainer and was powered by a 400-horsepower Pratt and Whitney R-985 engine. Popular with both students and instructors because of its then-novel enclosed cockpit, the BT-8 was considered sturdy and easy to fly.

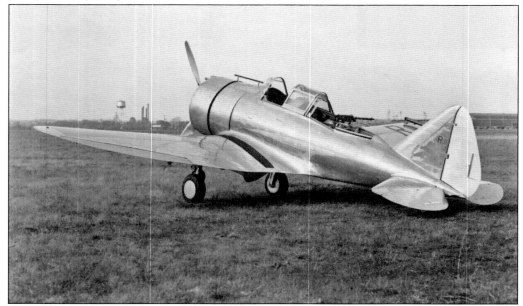

SEVERSKY 2PA CONVOY FIGHTER, 1937. The 2PA was a further refinement of the original Seversky design and was intended to be a two-place, long-range scout/bomber. It was built in both landplane and amphibian versions, and was powered by a 1,000-horsepower Wright R-1820 engines. Turned down by the U.S. Air Corps, 22 were sold to Russia and Japan as reconnaissance aircraft.

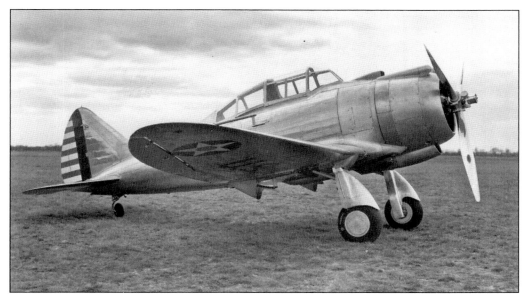

SEVERSKY P-35, 1937. Seversky's most successful aircraft to date was the P-35 fighter, of which 137 were delivered to the U.S. Army Air Corps in 1937 and 1938. The P-35 is noteworthy as being the U.S. Army Air Corps first all metal fighter with retractable landing gear and an enclosed cockpit. An additional 60 fighters were delivered to Sweden as the P-35A. It was powered by an 850-horsepower Wright R-1830 engine. By the beginning of 1942, all had been withdrawn from frontline fighter squadrons.

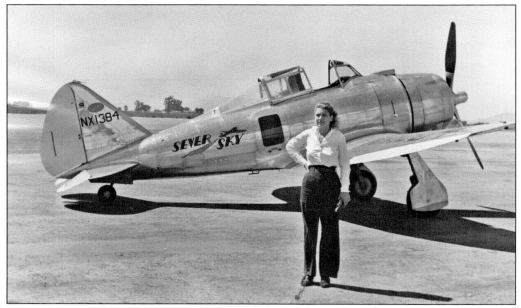

SEVERSKY AP-7, 1938. Seversky also built a successful line of racing aircraft in the late 1930s in order to get maximum publicity for the company. The AP-7, a company demonstrator, was built in 1938 and was flown by noted aviatrix Jacqueline Cochran (seen here) to victory in the 1938 Bendix Trophy Race. Equipped with a 1,200-horsepower Pratt and Whitney engine, it was the ultimate development of the P-35 design.

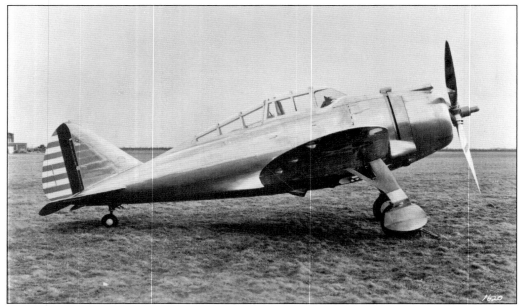

SEVERSKY XP-41, 1939. The last P-35 built was heavily modified by Seversky under a U.S. Army contract into a new design, the XP-41. The aircraft was now equipped with a new center section, fully retractable landing gear, a revised canopy, and a much more powerful supercharged 1,150-horsepower Pratt and Whitney R-1830 engine. Although never placed into production, this aircraft was the critical link that ultimately led to the P-47 Thunderbolt of World War II fame.

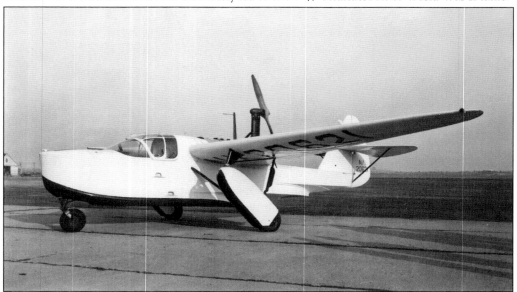

SPENCER-LARSEN AIRCRAFT CORPORATION SL-12C, 1939. This firm was founded in Amityville by Percival Spencer in 1937 with the desire to produce a superior amphibian. He developed the SL-12C, a unique design with the engine buried inside the hull and connected to the propeller on a jointed shaft. A two-place pusher amphibian with an enclosed cockpit, the aircraft's wing floats had wheels inside them and could be tilted back for water landings. Powered by a 125-horsepower Menasco engine, only one SL-12C was built.

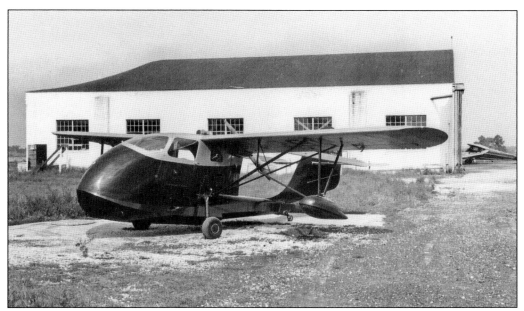

SPENCER AIR CAR, 1940. After the Spencer-Larsen firm dissolved in 1940, Percival Spencer developed a new, low cost amphibian in Amityville—the Spencer Air Car. A simple, robust design, it was built largely of wood. Spencer went to work for Republic Aviation during World War II, and he sold them the manufacturing rights to the Air Car. Republic later produced the design as the Seabee, with Spencer remaining as chief engineer on the project. (Courtesy John Underwood.)

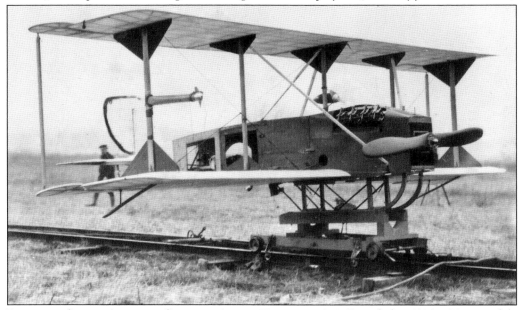

LAWRENCE SPERRY AIRCRAFT COMPANY AERIAL TORPEDO, 1918. Founded in 1916 in Farmingdale by Lawrence Sperry (son of inventor Elmer Sperry), Sperry built a small, but diverse number of aircraft through 1923. The first products were experimental Aerial Torpedoes designed for the navy as unmanned flying bombs. Test launched successfully off the south shore of Long Island during World War I, they can be considered direct ancestors of today's cruise missiles.

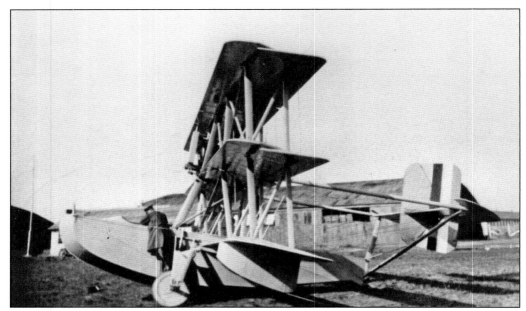

SPERRY TRIPLANE AMPHIBIAN, 1918. Designed for the navy as a coastal reconnaissance/bomber, it was built too late for wartime production, and only one was constructed. Powered by a 400-horsepower Liberty engine, it was one of the first practical amphibians, and in spite of its ungainly appearance, it was considered stable, easy to fly, and surprisingly fast.

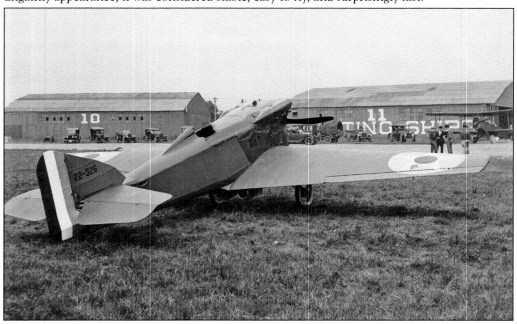

SPERRY-VERVILLE R-3 RACER, MITCHEL FIELD, 1922. A highly streamlined aircraft, the R-3 was a precursor to fighter designs of the 1930s. It was also the first monoplane with retractable landing gear, and it briefly held the world's speed record. Three were built for the army, with one winning the 1924 Pulitzer Trophy Speed Race. They were originally powered by 400-horsepower Wright H-3 engines. The 1924 winner was powered by a 500-horsepower Curtiss D-12.

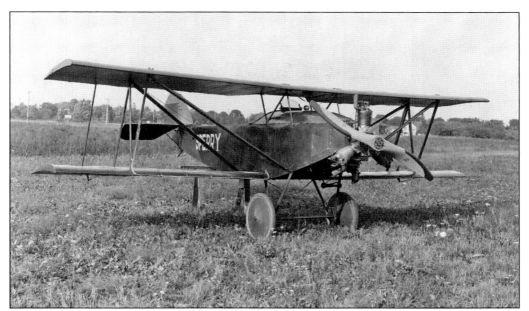

SPERRY M-1 MESSENGER, 1921. Sperry's largest and most lucrative contract was for 42 Messengers for the U.S. Army Air Service in 1921. A small, general-purpose biplane, it was intended to be used as an aerial motorcycle to deliver messages from improvised airstrips. Lawrence Sperry kept one in the garage of his Garden City home, and he flew it off the street to visit his Farmingdale plant. This short-lived, but promising firm dissolved in 1923 upon the untimely death of Lawrence Sperry.

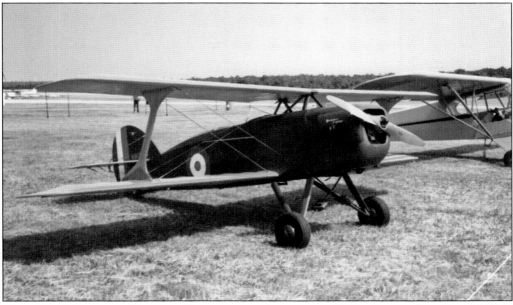

WOLF W-11 BOREDOM FIGHTER, BROOKHAVEN AIRPORT, C. 1990. Designed by Donald Wolf of Huntington in 1979, the Boredom Fighter is an all-wood, fabric-covered, single-place, World War I–look-alike, homebuilt aircraft. Usually powered by a 65-horsepower Continental A-65 (although some have had automobile engines), plans have been made available to other homebuilders. Dozens have been built and flown worldwide to this day.

DISCOVER THOUSANDS OF LOCAL HISTORY BOOKS
FEATURING MILLIONS OF VINTAGE IMAGES

Arcadia Publishing, the leading local history publisher in the United States, is committed to making history accessible and meaningful through publishing books that celebrate and preserve the heritage of America's people and places.

Find more books like this at
www.arcadiapublishing.com

Search for your hometown history, your old stomping grounds, and even your favorite sports team.